IMAGES of America
CHEYENNE
1867–1917

ON THE COVER: Cowboys are pictured racing down Capitol Avenue during Frontier Days. (J. E. Stimson Collection, Wyoming State Archives, Department of State Parks and Cultural Resources.)

IMAGES of America
CHEYENNE
1867–1917

Nancy Weidel

Copyright © 2009 by Nancy Weidel
ISBN 978-0-7385-5893-6

Published by Arcadia Publishing
Charleston, South Carolina

Printed in the United States of America

Library of Congress Catalog Card Number: 2008928329

For all general information contact Arcadia Publishing at:
Telephone 843-853-2070
Fax 843-853-0044
E-mail sales@arcadiapublishing.com
For customer service and orders:
Toll-Free 1-888-313-2665

Visit us on the Internet at www.arcadiapublishing.com

This book is dedicated to Ariana Weidel, the first Weidel to be born in Cheyenne, September, 13, 2007.

CONTENTS

Acknowledgments		6
Introduction		7
1.	Magic City of the Plains	9
2.	Work and Play	27
3.	The Rich Are Different	43
4.	School Days and Sundays	57
5.	Fort D. A. Russell	65
6.	Big Fish in a Small Town	71
7.	Out and About	79
8.	When Giants Ruled the Earth	83
9.	The New Century	97
10.	Frontier Days	115
Bibliography		126

ACKNOWLEDGMENTS

All images are from the collection of the Wyoming State Archives, Department of State Parks and Cultural Resources. All Stimson images are from the J. E. Stimson Collection at the Wyoming State Archives, Department of State Parks and Cultural Resources. I would like to thank the staffs of the Wyoming State Archives and the Wyoming State Library for their assistance. Both the archives and the library are wonderful places for conducting research. Thank you to Jim Ehernberger and A. J. Wolff for sharing their vast knowledge of the Union Pacific Railroad with me. I am grateful to Mary Hopkins, computer guru extraordinaire, for guiding me through a computer nightmare! Special acknowledgment goes to Bill Dubois, Jim Ehernberger, Sharon Lass Field, Shirley Flynn, and Bill O'Neal whose previous works made my job easier. Thank you to Kelly Reed of Arcadia Publishing for her patience and understanding.

INTRODUCTION

Cheyenne's history never gets old. It is an exciting tale of young men who staked their futures on the young city and participated in, and even steered, its growth from a frontier cow town to a sophisticated small city within an amazingly short period of time. It is a multifaceted history.

The few images that survive of the 1867 tent town are grainy but powerful. They convey a sense of the hustle-bustle of the rough frontier and the temporary nature of the "Hell on Wheels" towns that sprang up in the wake of the Union Pacific tracks on their westward march. Yet Cheyenne was different from those other towns because it was here to stay, as a result primarily of the railroad's designation of it as a division point. The Union Pacific Railroad's presence stabilized Cheyenne's economy through good times and bad, employing more than 2,500 people at its peak. The importance of the Union Pacific Railroad to Cheyenne cannot be overstated.

The burgeoning cattle industry played a major role in the first two decades of Cheyenne's history. It is this story that captivates so many. Most early leaders were involved in the profitable cattle industry, and Cheyenne was the place where the business got conducted. Wealthy men from back east and the British Isles, Civil War veterans, and those just looking for a new start in life came to Cheyenne to participate in the boomtown. The exclusive Cheyenne Club, constructed in 1881, epitomized this brief era, which quickly ended when the cattle market went bust in 1886–1887 because of overgrazing on the public land, a particularly harsh winter, and an overinflated market. Some men who lost their fortunes left town, never to return. Others, like Francis E. Warren, weathered the bad times and stayed on to become business, political, and civic leaders.

The military has always had a part in Cheyenne's history. Fort David A. Russell was created in tandem with the town in 1867 to protect railroad workers from Native American attacks as they laid the railroad track through southeast Wyoming. The location of a nearby fort meant Cheyenne merchants had a built-in clientele who contributed to the money pouring into town during the first 20 years of the city's existence.

Cheyenne grew by leaps and bounds during the 1880s, from a population of 3,456 in 1880 to about 12,000 by 1890. The early years of the decade were boom times in the town as well as the cattle industry. Large mansions constructed for the city's wealthy families lined Carey Avenue and Seventeenth Street, and new businesses sprang up along Sixteenth and Seventeenth Streets, increasing the size of the downtown. In 1882, the new opera house attracted Cheyenne's elite and conveyed status to the small city. Construction of the new Union Pacific Depot and the Capitol Building in the late 1880s solidified the city's leading economic and political role in Wyoming Territory, which was designated a state in 1890.

In the early 1890s, the Union Pacific Railroad sunk more than $1 million into a large expansion of their Cheyenne shops and yards, which produced over 200 new jobs and furthered their influence in the city. Along with Cheyenne, Fort D. A. Russell's population also grew following a burst of construction during the previous decade. Wyoming finally achieved statehood in 1890, which secured Cheyenne's economic and political dominance in a state with 92,531 residents by 1900.

Perhaps the decade is best remembered for the establishment of a long-lasting Cheyenne tradition: Frontier Days. What began as a one-day event in 1897 has grown over the years to encompass 10 days in July and continues to support the city's economy and put Cheyenne on the map for millions of people over the years. Frontier Days is now, much as it was in 1897, a time of hustle-bustle in Cheyenne that is eagerly anticipated by the thousands of visitors who pour into town each year.

Cheyenne experienced a building boom in the first two decades of the 20th century that smoothed out the city's rough edges and transformed the downtown into a modern metropolis. Construction of a first-class hotel (the Plains), the Carnegie Library, the Majestic and Gleason Buildings, the Boyd Building, the Federal Post Office, and the Stock Growers National Bank all conferred status and prestige upon Cheyenne as Wyoming's number-one city in the new century.

By the time Cheyenne reached the half-century mark in 1917, many of its pioneers had passed on, but a few like Frances E. Warren and Joseph Carey were still very much alive. These men, and others like them, had possessed the vision and drive to lead the "Hell on Wheels" settlement to become more than just another tent town alongside the railroad tracks. Over the past 50 years, they had seen Cheyenne earn its nickname and truly become the "Magic City of the Plains."

One
MAGIC CITY OF THE PLAINS

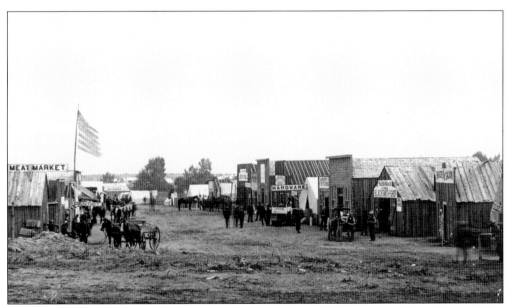

TENT TOWN: SIXTEENTH STREET, 1867. In 1867, Gen. Grenville Dodge, chief engineer for the Union Pacific Railroad, selected the site of Cheyenne as a division point for the railroad because of its location at the foot of the Rocky Mountain chain. Dodge named the site Cheyenne after the tribe roaming the nearby plains. As construction of the railroad moved closer to the newly named Cheyenne, the future town attracted hundreds of people eager to make a fast buck. Speculators, gamblers, prostitutes, and other riffraff conducted business in the tent town that quickly arose.

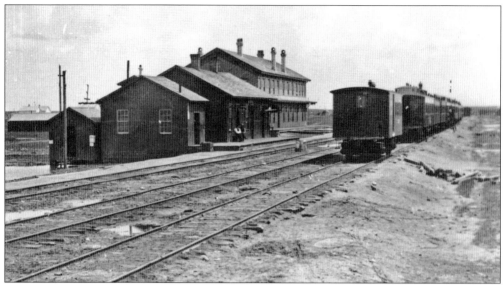

THE FIRST UNION PACIFIC HOTEL AND DEPOT, 1869, LOOKING EAST. Within one year of the Union Pacific tracks reaching Cheyenne, the railroad built a hotel and restaurant to accommodate travelers. The hotel cost $23,000. The one-story frame depot stood just to the west of the hotel. A fire in December 1871 consumed the hotel, which the Union Pacific rebuilt for $25,000. The hotel burned to the ground in November 1886. Note the main line consisting of only two tracks.

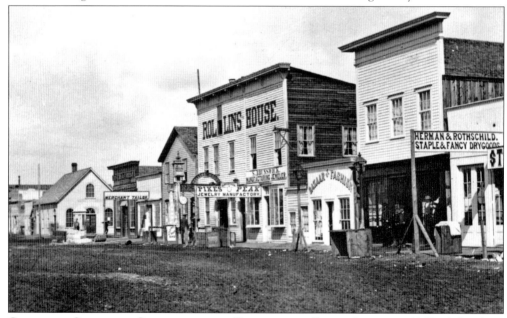

CHEYENNE, SIXTEENTH STREET BETWEEN PIONEER AND CAREY AVENUES, 1868. A few short months after Cheyenne's establishment as an end-of-the-tracks "Hell on Wheels" tent town, legitimate businesses had sprung up. The Rollins House was one of the city's first hotels. The second Wyoming Territorial Legislative Assembly met here in 1871. The framed false fronts on a number of buildings became emblematic of Western frontier towns and conveyed the appearance of a more permanent structure than the logs with which many were built. The city grew so fast that a newspaper reporter named it the "Magic City of the Plains."

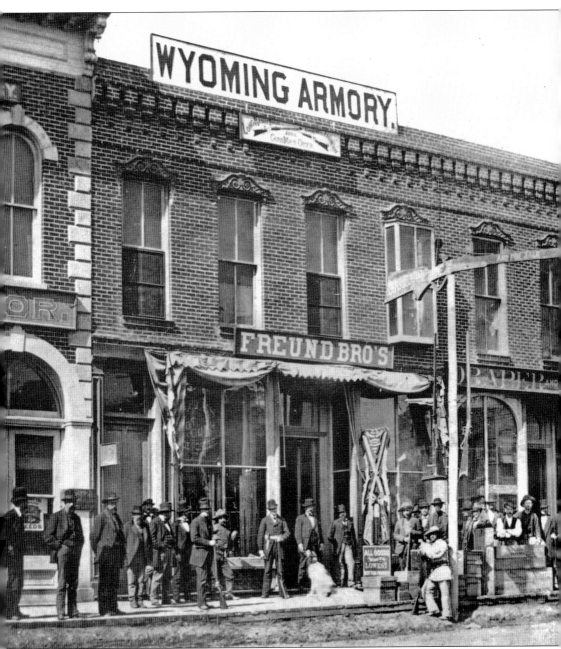

FREUND BROTHERS, WYOMING ARMORY, CAREY AVENUE BETWEEN SIXTEENTH AND SEVENTEENTH STREETS, 1877. Two of the most famous gunsmiths of the Wild West, Frank and George Freund had stores in towns along the Union Pacific route as well as in Denver. In the 1868 Business Directory of Cheyenne, the brothers advertised: "Manufacturers of Guns, Pistols and Cutlery . . . Sporting Apparatus, and all kinds of Fixed and Loose Amunition [sic], Double and Single barreled Rifles and Shot Guns made to order. Every kind of repairing done with neatness and dispatch. . . . Agents for E. I. Dupont's and Denemour & Co.'s Celebrated Sporting and Mining Powder." Both brothers left Cheyenne sometime after opening the store, although Frank returned in 1875. He and his family remained in Cheyenne until 1885, when he sold out and left Wyoming.

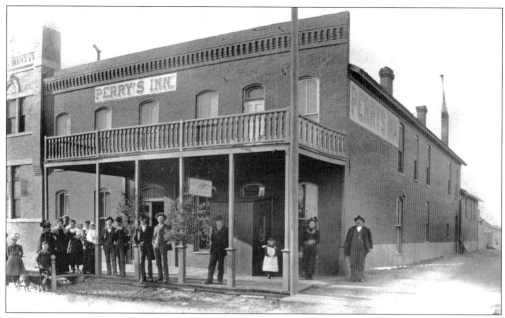

PERRY'S INN, 1608–1610 THOMES AVENUE. Not everyone who visited Cheyenne could afford to stay at the first-rate InterOcean Hotel. Various establishments near the Union Pacific Depot and elsewhere catered to a different class of traveler. Perry's Inn, located west of the core downtown area, was one such place. A. J. Perry and Cynthia Jane Perry first operated the hotel, and J. A. Zachary took over as proprietor sometime before 1902. The inn was located next door to the Eagles Building.

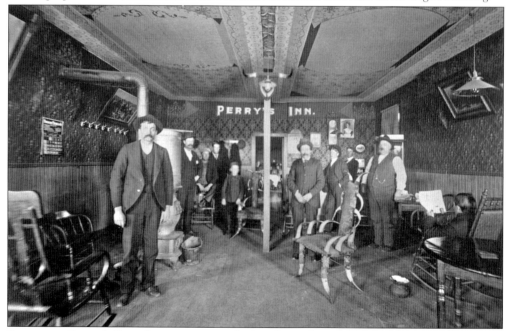

INTERIOR, PERRY'S INN. It was common for hotels to also rent rooms. In 1902, Perry's Inn advertised in the Cheyenne City Directory: "If you want a Good Meal, or A Nice Clean Bed go to . . . Perry's Inn." Room and board cost $1 a day, $5 a week, or $20 a month. The inn included a dining room and kitchen. Perry's Inn burned down sometime after 1912.

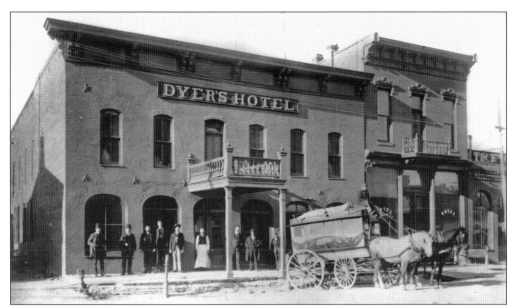

DYER'S HOTEL, 1614–1616 PIONEER AVENUE. Irish immigrant Tim Dyer was 19 years old when he came to Cheyenne in 1867. He bought a small restaurant on Pioneer where he eventually built the Dyer House. He lost the building in the 1870 fire that consumed more than two square blocks of downtown. Another fire in 1875 prompted Dyer to side his frame building with brick. The Dyer Hotel was constructed in 1868 and still doing business in 1912 at the same location. Tim Dyer became a prominent businessman and citizen, serving on the first board of directors of the Cheyenne Opera House and Library Hall Company.

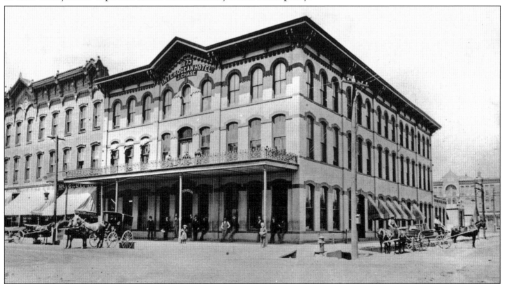

THE INTEROCEAN HOTEL, NORTHWEST CORNER OF SIXTEENTH STREET AND CAPITOL AVENUE. African American Barney L. Ford, a former slave, moved to Cheyenne from Denver where he owned the InterOcean Hotel, which opened in 1875. For years, the InterOcean was Cheyenne's premier hotel. Famous guests included Presidents Teddy Roosevelt and Ulysses S. Grant and actors Edwin Booth and Sara Bernhardt. The arrest of the notorious Tom Horn took place at the InterOcean. The Hynds Building is now in this location.

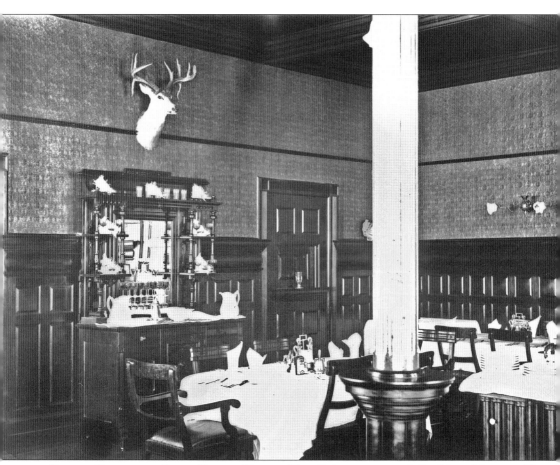

Dining Room, the InterOcean Hotel. The dining room specialized in wild game. The opening night menu featured different kinds of fish and boiled meats, five game meats, oysters, 20 kinds of entrees, and 50 different desserts. Although extremely popular, the InterOcean Hotel was not profitable for Barney Ford, and he returned to Denver.

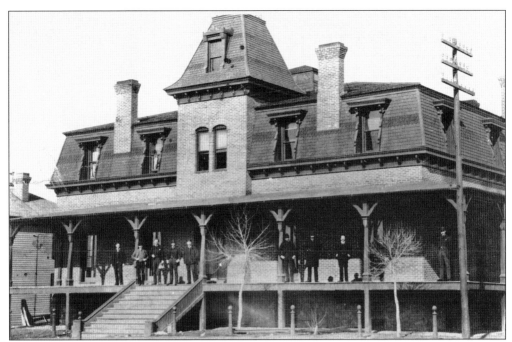

THE CHEYENNE CLUB, 1888. Established by 12 cattlemen in 1880, the Cheyenne Club opened in April 1881 on the northwest corner of Seventeenth Street and Warren Avenue. A gathering place for Wyoming's far-flung wealthy ranchers, the brick clubhouse featured two wine cellars, double parlors, a dining room, library, smoking room, and billiard room as well as sleeping quarters on the top floor. One member described the club as "a brilliant scene. . . . Wine flowed freely, tongues got limber." Charter members included many of Cheyenne's elite, such as Francis E. Warren, Joseph M. Carey, W. C. Irvine, and A. R. Converse.

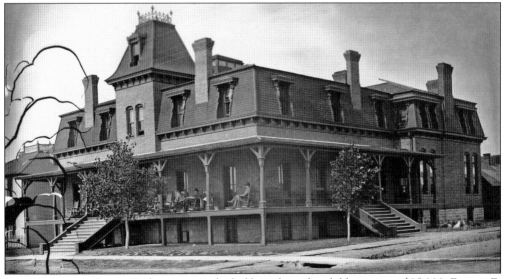

THE CHEYENNE CLUB. Built on one and a half city lots, the clubhouse cost $25,000. Francis E. Warren, representing his firm, F. E. Warren and Company, personally selected the $12,500 worth of furnishings in New York City. The large city lot included a cottage at the rear for servants and 19 hitching posts. Members played tennis at courts just west of the clubhouse.

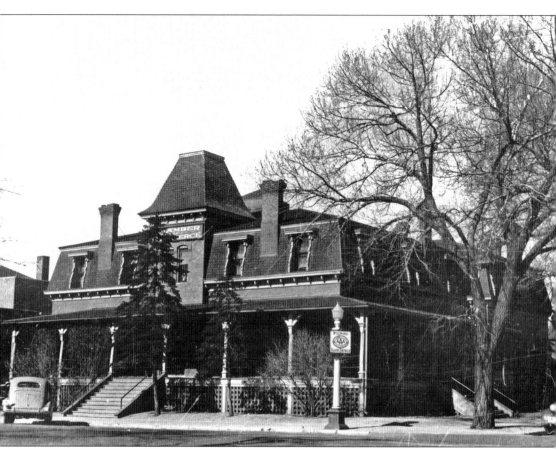

THE CHEYENNE CLUB AS THE CHAMBER OF COMMERCE, C. 1930. The harsh winter of 1886–1887 proved disastrous to the range cattle industry. The Cheyenne Club faced hard times as many of the wealthy pioneer members left Cheyenne, never to return. The Industrial Club, precursor of the Cheyenne Chamber of Commerce, eventually took over the building as its headquarters. The old clubhouse building was razed in 1936, and a new chamber of commerce building was constructed on the site.

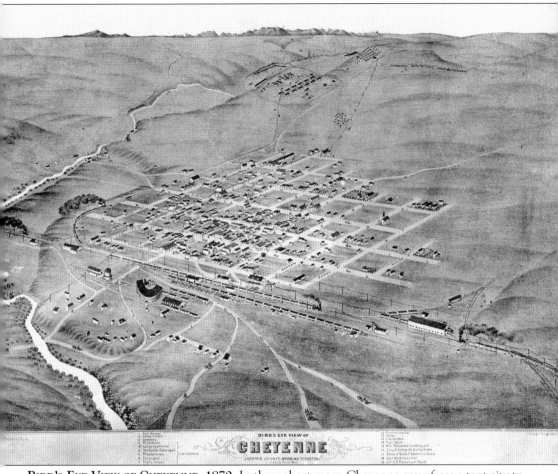

BIRD'S-EYE VIEW OF CHEYENNE, 1870. In three short years, Cheyenne grew from a tent city to a thriving town on the high plains. The Union Pacific had built a roundhouse, a shop building, and the two-story Pacific Railroad Hotel and Restaurant, which stood just north of the tracks at the intersection of Fifteenth Street and Central Avenue (Ranson Street on the map). The one-story frame depot is just west of the hotel. The First United Methodist Church building is located on the northeast corner of Eighteenth Street and Central Avenue. Camp Carlin and Fort D. A. Russell are beyond the town at the upper center of the drawing. The town had expanded to Twenty-first Street on the northern edge and Bent Street on the west side. (Stimson.)

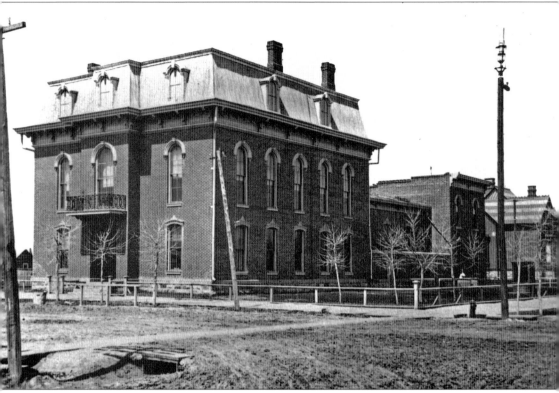

Laramie County Courthouse, Northwest Corner, Nineteenth Street and Carey Avenue. Constructed in 1875, the building was Laramie County's first courthouse. The third Wyoming Territorial Assembly met here in 1873 with Frances E. Warren as president. The French-inspired mansard roof was a popular post–Civil War design in urban areas of the East and Midwest. The 1917 Laramie County Courthouse, designed by Cheyenne architect William Dubois, now occupies this corner.

LOOKING SOUTH FROM TWENTIETH STREET, C. 1882. Capitol Avenue runs to the south on the right side of the photograph. The Cheyenne Opera House (building "5") is just three blocks south at Seventeenth Street and Capitol Avenue. The InterOcean Hotel is the large building south of the opera house. The Congregational Church (building "1") is on the northwest corner of Nineteenth Street and Capitol. The Baptist Church (building "2") is on the southeast corner of Eighteenth Street and Carey Avenue. Note how close the residential district is to downtown. Most of the houses are modest, one-story frame dwellings, although a few are two-story brick residences like the one on the left in the photograph.

FIFTEENTH STREET, 1880S. Saloons, cheap hotels (other than the Metropolitan Hotel), and restaurants lined Fifteenth Street along the two blocks west of the Union Pacific Depot in the 1880s. It was not an area genteel women frequented, although one could find "ladies of the night" at a number of the businesses. Farther west were warehouses and frame dwellings.

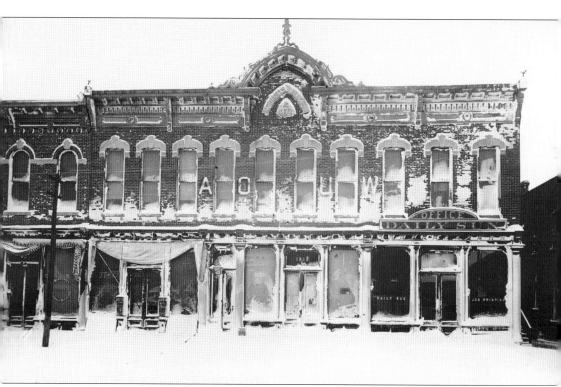

McDaniel's Theatre, 1613–1623 Pioneer Avenue. James McDaniel, theater impresario, arrived in Cheyenne in 1867 from Denver, where he had established a theater. The self-proclaimed "Barnum of the West" opened his Cheyenne theater that same year, which combined a saloon, theater, and a museum of curiosities where patrons could view such wonders as a grizzly bear, a dwarf, and a visit by Tom Thumb. The theater hosted Shakespeare plays and opera performed by traveling troupes. Fire consumed his first theater, and he opened this brick building in 1877. Until the construction of the Cheyenne Opera House, McDaniel's was Cheyenne's premier theater.

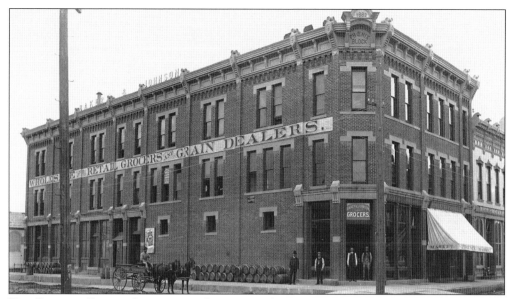

THE PHOENIX BLOCK, SOUTHWEST CORNER OF SIXTEENTH STREET AND CAPITOL AVENUE. Constructed in 1882, the Phoenix Block was part of F. E. Warren's downtown real estate holdings. Baker and Johnson Groceries occupied most of the first floor on the Sixteenth Street side. The second floor housed 17 offices and 27 family rooms made up the third floor. The building cost an estimated $35,000. It later became the Normandie Hotel and is now the home of Corral West.

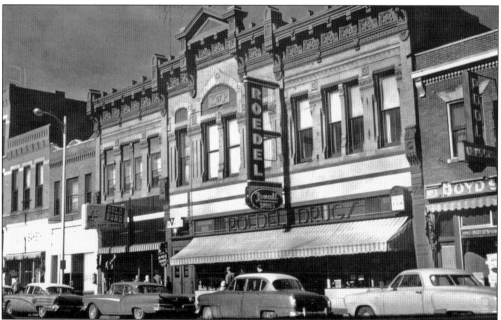

KNIGHTS OF PYTHIAS BUILDING, 312 WEST SEVENTEENTH STREET, 1960. Fraternal organizations played an important role in Cheyenne. Similar to the Masons and the Elks, the Knights of Pythias attracted men interested in serving their community. The lodges also functioned as meeting places where one could make business and social contacts. Prominent Cheyenne men joined the Knights organization. Roedel's Drugs occupied the first floor for many years. The left side of the 1886 building is still visible today.

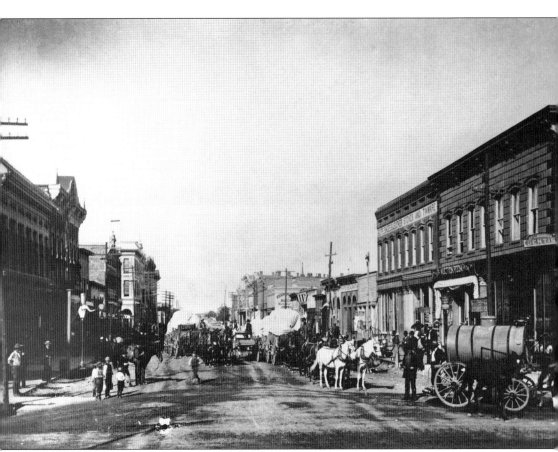

FREIGHT TEAMS LEAVING CHEYENNE, SIXTEENTH STREET AND CAREY AVENUE. Other than the Union Pacific Railroad's line across southern Wyoming, no other railroads existed to deliver supplies to Fort Laramie and ranches north and northeast of Cheyenne. Everything from groceries to lumber to liquor had to be freighted by either the military from Camp Carlin or private companies in Cheyenne. When the Black Hills gold rush began in 1876, Cheyenne became the jumping-off point for gold seekers who traveled to Deadwood and Custer City. Four hundred freight wagons operated out of Cheyenne. The city's merchants, F. E. Warren, Erasmus Nagle, I. C. Whipple, and Joseph Carey, prospered as they supplied tons of goods to the military and the miners.

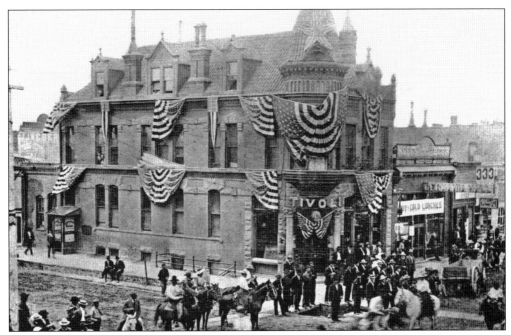

The Tivoli Building, 301 West Sixteenth Street. Constructed in the 1880s on the prominent southwest corner of Sixteenth and Carey Avenue, the Tivoli was owned by Warren Richardson, who arrived in Cheyenne as a boy in the 1870s. Warren used the second floor as his office. The building also housed a restaurant and bar, and prostitutes reportedly occupied the third floor. Cheyenne women gathered at the Tivoli for afternoon tea. Here the Tivoli is festooned with bunting and a crowd is gathered, perhaps for a Frontier Days parade.

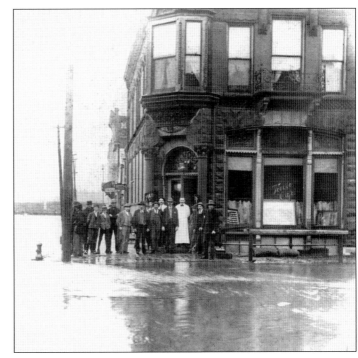

Flood outside the Tivoli, Southwest Corner of Sixteenth Street and Carey Avenue. Major flooding occurred in 1883 and 1884 in the downtown and surrounding residential areas. Bales of hay and sacks of bran, flour, and salt were used to create dams that might protect a building's basement and foundation from the rushing water. The channel of Crow Creek was eventually deepened as a preventive measure to help control the larger floods in the downtown. Note the multistory structure south of the Tivoli. Today one-story buildings occupy this area.

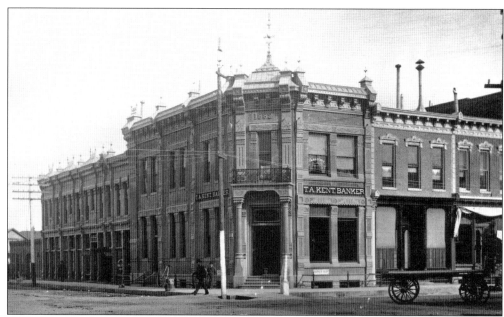

T. A. Kent Building, Southeast Corner of Seventeenth Street and Carey Avenue. T. A. Kent, like a number of Cheyenne's successful businessmen, began his career in Cheyenne by selling liquor at his store at Sixteenth Street and Pioneer Avenue. He went on to become a banker and opened a private bank in his own building, constructed in 1882. The bank eventually failed. The downtown mall now occupies the lot where the T. A. Kent Building once stood.

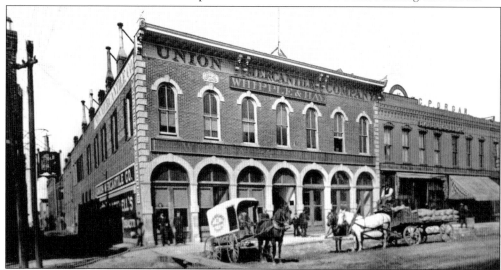

The Union Mercantile Company, West Side of Carey Avenue between Sixteenth and Seventeenth Streets. Erected in the 1870s, the Union Mercantile housed Whipple and Hay Wholesale Grocers. I. C. Whipple and Henry Hay each made a fortune in the grocery business during the 1870s. The Black Hills gold rush proved to be a gold mine for businessmen like F. E. Warren, Erasmus Nagle, and Whipple and Hay, who all supplied tons of merchandise, supplies, and groceries to hundreds of freight wagons making their way to Deadwood. Whipple's house still stands at 302 East Seventeenth Street. Hay bought Joseph Carey's first house on Carey Avenue after Carey built his opulent mansion across the street. Hay's house later became a private hospital.

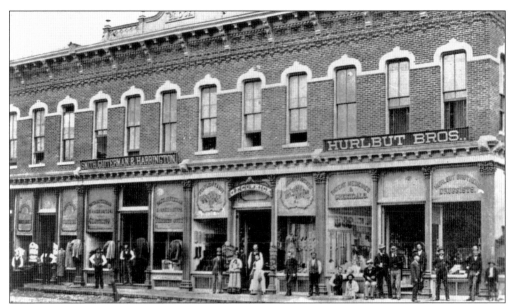

THE CAREY BLOCK, NORTHWEST CORNER OF SEVENTEENTH STREET AND CAREY AVENUE. It seems as if every successful businessman had a block constructed in the 1870s and 1880s that bore his name. The Carey Block was constructed in 1876 on a prominent downtown corner and housed the Stock Growers National Bank as well as a clothing store, a harness shop, and offices on the second floor. Joseph M. Carey founded the bank along with his brother David, the Sturgis brothers, and Henry Hay, who served as president. The bank remained in this building until the new Stock Growers National Bank was built in 1905 on the northeast corner of Seventeenth Street and Capitol Avenue. Note the rolled-up awnings on the storefronts and the muddy streets. The Carey Block still stands today, next to the Knights of Pythias Building, although it has been sheathed in pink metal siding.

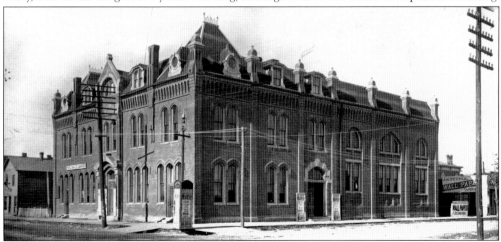

THE CHEYENNE OPERA HOUSE, NORTHWEST CORNER OF SEVENTEENTH STREET AND CAPITOL AVENUE. The grand opening of the Cheyenne Opera House on May 25, 1882, was a significant event in the city's early history. The opera house, which sat 860, occupied two-thirds of the large building and fronted on Capitol Avenue. Interior appointments included a large chandelier, carved woodwork, and a grand staircase to the balcony. The Territorial Library and the *Cheyenne Daily Leader* newspaper rented the ground floor on the Seventeenth Street side, and the two large halls above could accommodate banquets and dances. The Territorial Library occupied the third floor.

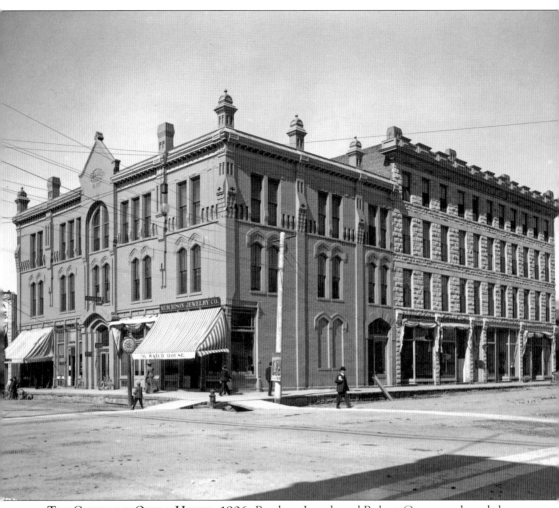

The Cheyenne Opera House, 1906. Brothers Joseph and Robert Carey purchased the opera house from Frances E. Warren in 1891 and remodeled it substantially with a new third story and less ornate roof. In addition to the opera house, the building now offered 26 offices and four ground-floor storefronts. A fire in 1902 destroyed the opera house, although the Seventeenth Street side remained. Rather than rebuild the unprofitable theater, the Carey brothers constructed a four-story building with commercial, office, and apartment space on the Capitol Avenue side. The Opera House Block was razed in the 1960s to make way for the new J. C. Penney store.

Two

WORK AND PLAY

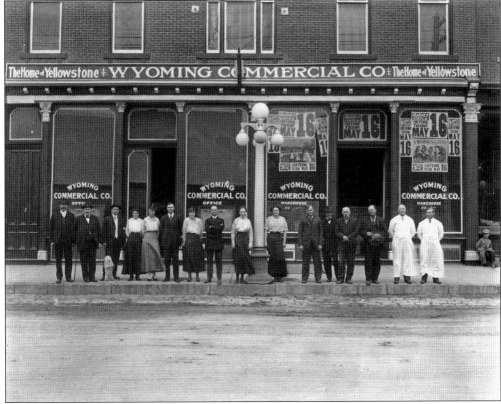

WYOMING COMMERCIAL COMPANY, C. 1917. The building housed the offices and warehouses of the liquor business that advertised "The Home of Yellowstone Whiskey." It is surprising so many women worked outside the home at this time. Notice the posters advertising the Barnes Circus coming to town on May 16. The circus performers and animals often paraded through Cheyenne's downtown when they came to town.

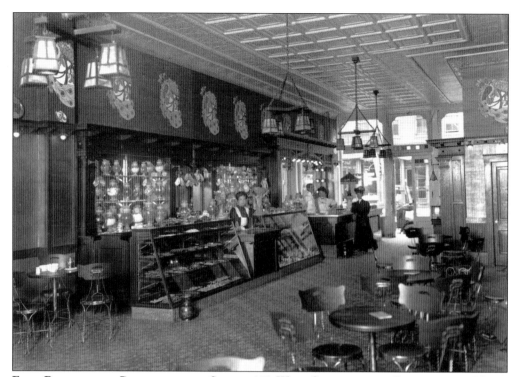

ELLIS BAKERY AND CONFECTIONERY STORE, 110 WEST SEVENTEENTH STREET, 1897. Henry H. Ellis had been in the bakery and confectionery business since he came to Cheyenne in 1868. According to an early-1880s report, the bakery sold 1,000 loaves of bread daily in the summer along with cakes and pies. Ellis employed two bakers and a confectioner year-round. He catered many parties, including the lavish open house hosted by Erasmus Nagle for his new Seventeenth Street mansion. An 1885 advertisement stated, "Parties supplied with Ice Cream, Water Ices, Jellies, Roman Punch, Biscuits, Glaces, Charlotte Russe, Macaroons, Lady Fingers." The store was a popular destination for the women of Cheyenne. It remained a family business until 1921. (Stimson.)

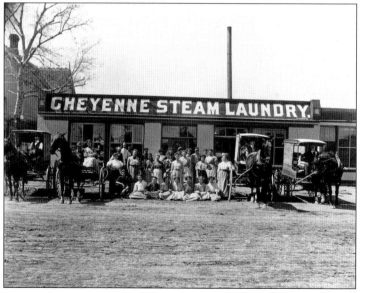

CHEYENNE STEAM LAUNDRY, EIGHTEENTH STREET AND O'NEIL AVENUE. The business was founded in 1884 by J. A. England and later run by his son Harold A. England and J. F. Rossman. Laundry cost 12.5¢ a shirt and 3¢ a collar at the time. The owners eventually added a second floor. The building burned in 1963 and was replaced by a new dry-cleaning building at the same location, since demolished.

THE BLACK AND TAN CLUB. Moving buildings was more common in Cheyenne's past than its present. Although the original location of the building is unknown, it was possibly one of the cattle baron's mansions on Carey Avenue, as it appears to be moving through a prosperous residential area. It may have taken a week or so to move the building to its new location at the southwest corner of Seventeenth Street and Snyder Avenue, where it still stands.

NATIONAL LUMBER COMPANY, TWENTIETH AND REED STREETS, 1917. By the 1910s, contractor Moses P. Keefe was so successful he owned the National Lumber and Mill Company in addition to a stone quarry west of town and a brick plant. He advertised in the 1917 Wyoming State Business Directory: "Lumber, Building Materials, Builders Supplies and Millwork, Wholesale and Retail, M. P. Keefe, Pres., E. J. Keefe, Secy." (Stimson.)

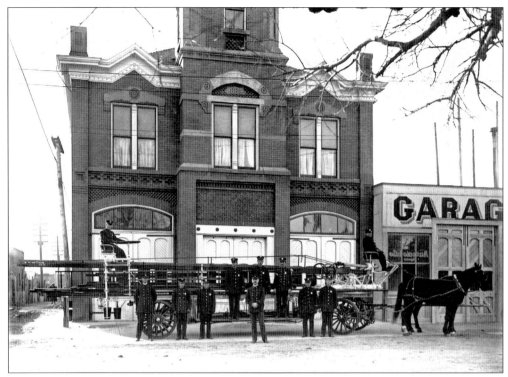

THE PIONEER HOOK AND LADDER COMPANY. The city's first fire volunteer company was formed in 1868 and sometimes worked alongside Fort D. A. Russell's Phil Sheridan Hose Company. The Pioneer Hook and Ladder Company's firehouse was located at 1712–1714 Pioneer Avenue. The company sold tickets for their ball in 1878 in order to purchase "heavy rubber overcoats" that would help protect the volunteers' clothing. In the photograph, the firemen are dressed in their parade uniforms and perhaps displaying a new ladder. The Union Pacific organized the Clark Hose Company in the 1870s, the only company on Cheyenne's south side.

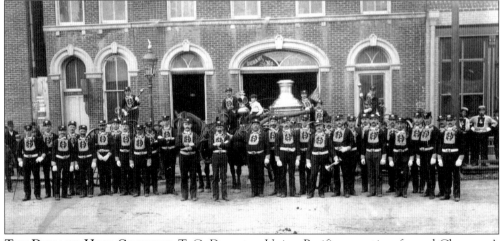

THE DURANT HOSE COMPANY. T. C. Durant, a Union Pacific executive, formed Cheyenne's second volunteer fire company in early 1869. He donated the lumber for the company's first building. Each of the city's four fire companies had their own distinct uniforms, which they wore in parades and at other formal events.

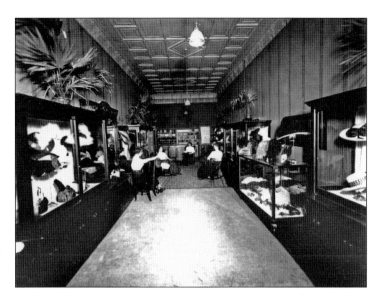

JAMES SISTERS MILLINERY PARLOR, 1710 CAREY AVENUE. Sisters Martha and Anna James operated their millinery store for many years. They catered to Cheyenne's wealthy women who wore hats for many formal as well as casual occasions. Note the pressed-tin ceiling, a common feature on the first floor of many 19th-century storefronts.

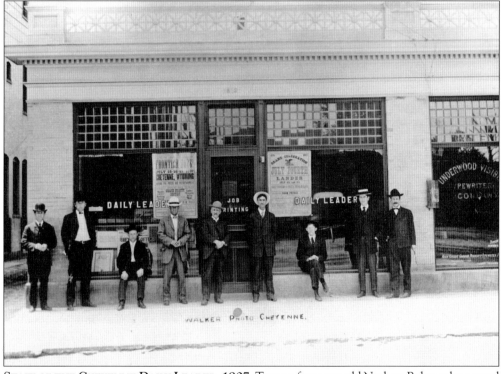

STAFF OF THE *CHEYENNE DAILY LEADER*, 1907. Twenty-four-year-old Nathan Baker, who moved to the boomtown from Denver, published Cheyenne's first newspaper, the *Cheyenne Leader*, on September 19, 1867. It soon became a daily paper, except for Sundays, and the name changed to the *Daily Leader*. Although other newspapers sprung up shortly thereafter, the *Daily Leader* remained the city's number-one newspaper for many years. The *Cheyenne Daily Leader* first occupied a false-fronted log building on Pioneer Avenue. They next moved to offices on the west side of O'Neil Avenue between Seventeenth and Eighteenth Streets and then relocated to 1612 Capitol Avenue by the time this photograph was taken. Cheyenne had three daily newspapers in 1907.

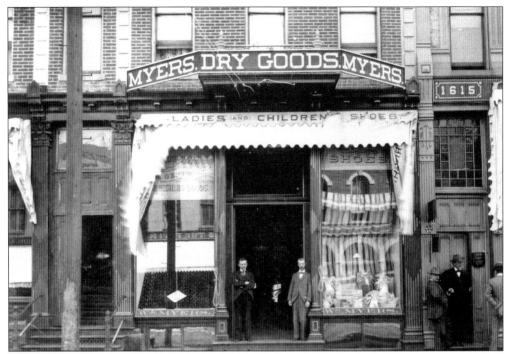

MYERS DRY GOODS, 1617 CAREY AVENUE. Storefronts like this one were common all along Sixteenth and Seventeenth Streets and Carey and Capitol Avenues in the late 1800s. Many had cast-iron fronts manufactured in such cities as Chicago and Minneapolis that arrived on the railroad. The second and third floors had separate entrances, like the doorway just to the left of Myers Dry Goods, which often contained boarding rooms or separate businesses.

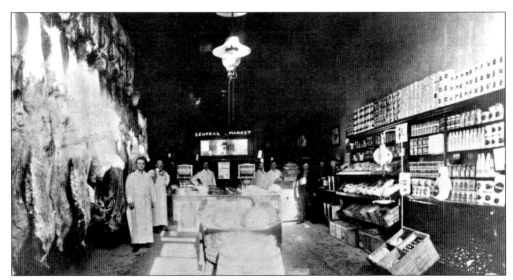

CENTRAL MARKET, 318 WEST SEVENTEENTH STREET. The Central Market was owned by David Nimmo and was also known as Nimmo's Meat Market. In addition to meat, the market sold vegetables, poultry, and other products. They were in business in downtown Cheyenne for many years. Nine meat markets served Cheyenne in 1906.

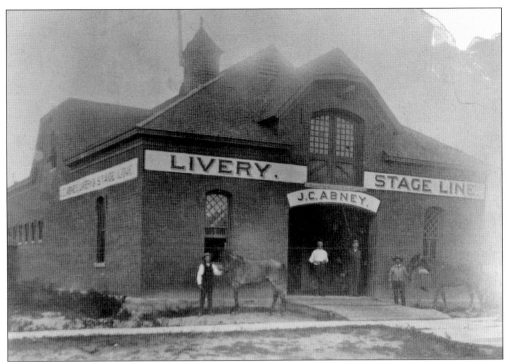

J. C. Abney Livery. J. C. Abney owned a large livery business in Cheyenne. He ran a weekly stage, mail, and passenger line between Fort Laramie and Cheyenne in 1874. Abney's passenger service was in demand once the Black Hills of South Dakota were opened to gold miners, who flooded into Cheyenne in 1876. On January 6, 1876, Abney advertised: "Those who want to start for the Black Hills this morning can be accommodated by Mr. Abney. He has room for a number of passengers, who will be permitted to walk behind his team; passage $5.00 each. Apply at the Elkhorn livery office."

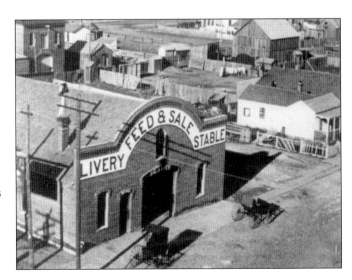

Another Abney Livery Stable, Sixteenth Street. Livery stables were an important component of towns and cities before the widespread use of automobiles. A person could board a horse there, and the livery stable was also a place where a visitor might "park" his horse and carriage for a few days. Many of Cheyenne's elite had livery stables on the grounds of their residences. The Cheyenne Club on Seventeenth Street is the large building at top center.

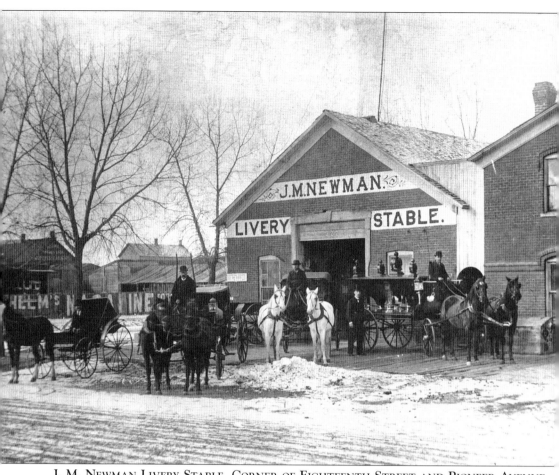

J. M. NEWMAN LIVERY STABLE, CORNER OF EIGHTEENTH STREET AND PIONEER AVENUE.
Once the automobile became commonplace, livery stables were often converted to garages where one could have an automobile serviced. Likewise, many private liveries became places to store the family car and were the precursors of the residential garage.

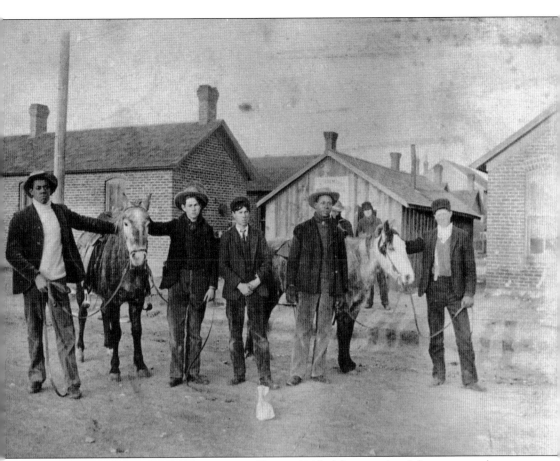

COWBOY RANCH HANDS HAVE A DAY ON THE TOWN, 1905. After months of the range, cowboys came into town and frequented saloons, brothels, and other establishments where they might purchase a new pair of boots or a saddle or have a haircut. One source estimates of the 30,000 or so cowboys in the West between 1866 and 1896, as many as 5,000 were African Americans who had come west to seek employment that may have been denied them in the newly emancipated South. Although discrimination existed, black cowboys shared the same bunkhouses as their white counterparts and received the same pay.

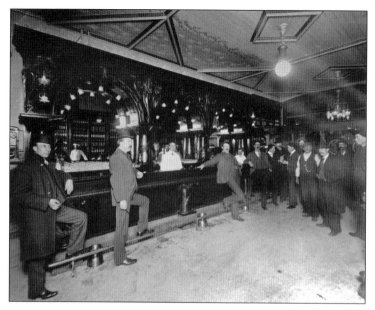

INTERIOR, THE TIVOLI BUILDING. Like many saloons of the day, the Tivoli featured an elaborate wood back bar. Note the lack of seating and the brass foot rail, which were common in bars of the period. Over the years, the Tivoli has been home to a real estate firm, the Amtrak station, and the chamber of commerce, and it is now being renovated for office space. The building is a landmark in downtown Cheyenne. (Stimson.)

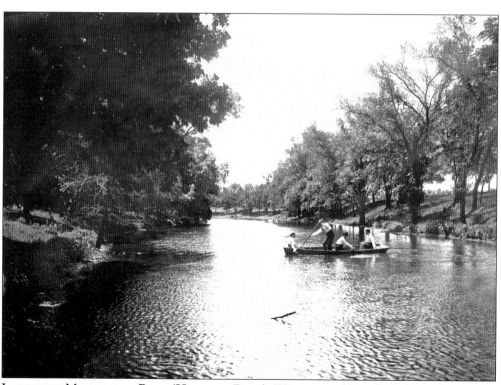

LAGOON IN MINNEHAHA PARK (HOLLIDAY PARK). Water carried by a ditch from Sloan's Lake on the northern outskirts of Cheyenne created the Minnehaha Lake and lagoons on the city's eastern border in 1882. On Arbor Day 1897, schoolchildren planted cottonwood saplings; some survive today. Boating on the lagoons became a popular activity as well as ice-skating in the winter. The lagoons were eventually filled in and only the lake remains. The park was renamed to honor Cheyenne mayor Cal Holliday in 1930.

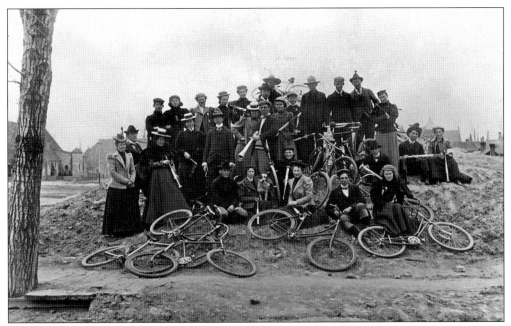

CHEYENNE BICYCLE CLUB. Recreational bicycling became popular for both men and women in Cheyenne by the 1890s. The development of the two-wheeler bike in the 1880s made the sport more attractive to women, who could navigate the vehicle in long skirts. Bicycles gave women freedom of mobility and were often seen as a symbol of female emancipation.

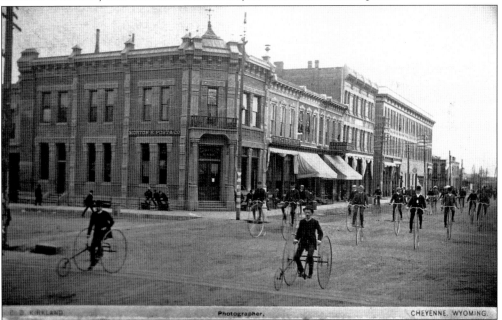

BICYCLES ON CAREY AVENUE AND SEVENTEENTH STREET, 1883. The bicycling craze first hit the United States and Cheyenne in the 1880s among the younger members of the upper class. The high-wheeler bicycle was known for its speed, which made it dangerous as one could become entangled in the large front wheel in an accident. The sport declined in popularity by the 1910s with the advent of the automobile.

Hose Company and Fire Cart. This is most likely an event in the competition among the four fire companies. The men are pulling the fire cart down Capitol Avenue. The capitol is visible in the background, as is Central School, the large building behind the gable-roofed house. The bystanders are behind ropes. (Stimson.)

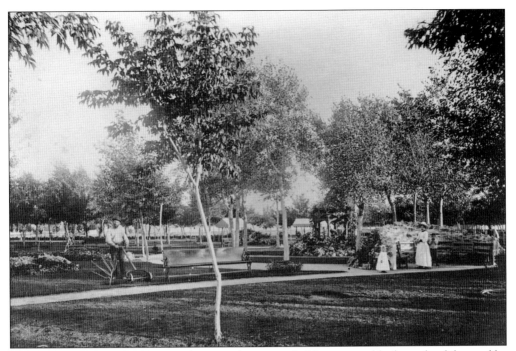

CHEYENNE CITY PARK. Cheyenne's city park consisted of four square blocks on land donated by the Union Pacific Railroad in 1867. The park was located between Twenty-second and Twenty-fourth Streets bordered by Warren and Capitol Avenues, where the Barrett Building and Supreme Court Building stand today. Tree planting began in earnest in 1882 once water could be accessed from the lakes to the north of the city.

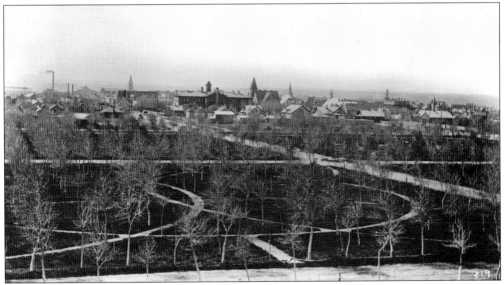

CITY PARK AT TWENTY-FOURTH STREET AND CENTRAL AVENUE. Features of the park included a path for carriages and bicycles, a fountain, a bandstand, and a stone grotto. A shelter in memory of Helen Smith Warren, the wife of Francis E. Warren, was constructed in 1902 and moved to Holliday Park in 1937 when the state campus expanded. The photograph was taken from the tower of the Holy Child of Jesus Academy.

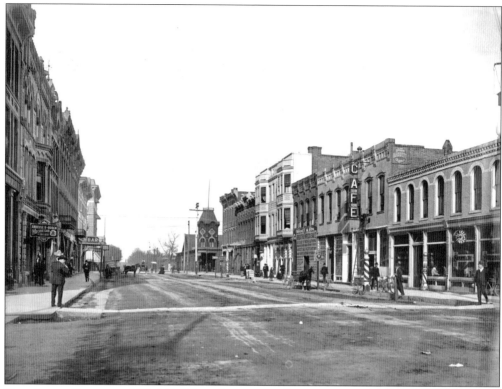

THE ATLAS THEATRE, 209–213 WEST SIXTEENTH STREET, 1908. The Atlas Theatre is the white building in the middle of the block on the right side of the photograph. Constructed in 1887, the Atlas housed a confectionery shop on the first floor and offices above until 1907. In that year, architect William Dubois produced drawings for a remodel of the building that included a theater at the rear to seat 550 people. Note the number of bicycles in the photograph. The Warren Emporium is the prominent building with the tower on the right.

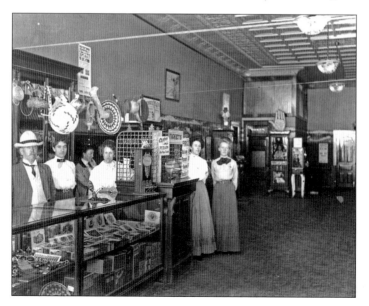

LOBBY, THE ATLAS THEATRE, 1908. Thomas Heaney, the proprietor of the Atlas in 1908, advertised "High Class Vaudeville Attractions . . . Curios and Souvenirs, Fountain Refreshments and Amusement Parlors . . . Cigars and Smokers' Articles." The sign for the women's lounge is visible in the rear next to the arcade machines. A group of employees pose for a photograph in the theater's lobby. (Stimson.)

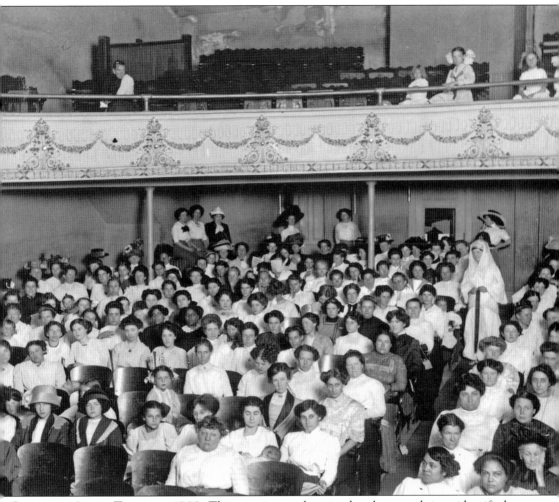

INTERIOR, ATLAS THEATRE, 1908. The occasion or show in the photograph is unidentified, but it certainly appealed to the women of Cheyenne. Photographs of African Americans in Cheyenne are uncommon, so it is especially interesting to note the African American women in the audience.

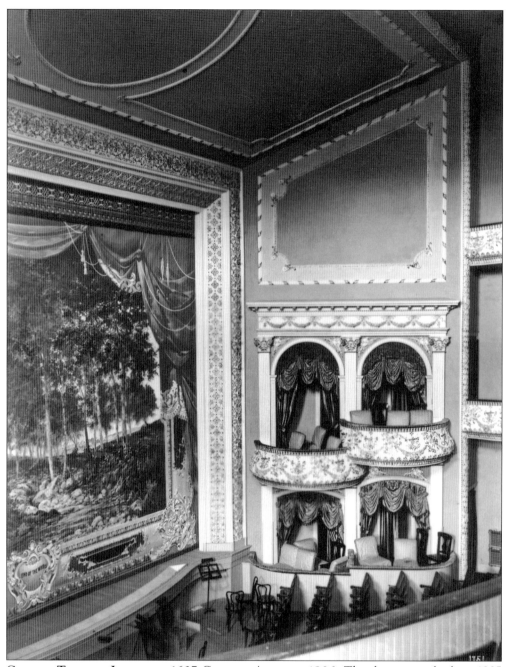

CAPITOL THEATRE INTERIOR, 1607 CAPITOL AVENUE, 1906. The theater was built in 1905 as a replacement for the Cheyenne Opera House, which burned down on December 8, 1902. Decorative elements in the interior included ornamented walls, eight boxes with rose satin curtains, and a semicircular loge. The theater was designed for traveling road shows and seated 1,140 patrons. A production of *Ben-Hur* featured live horses on a treadmill to simulate the chariot race. The building burned in 1915 and was rebuilt in a simpler style; it later became the Paramount movie theater. The large lobby area survives today, although the theater portion was destroyed by fire. (Stimson.)

Three
THE RICH ARE DIFFERENT

RENESSELAER SCHUYLER VAN TASSELL (1845–1931). One of Cheyenne's well-known figures, Van Tassell was born in New York and made his way to Wyoming Territory by 1865, where he worked as a tie cutter for the Union Pacific Railroad at Sherman Hill just west of the future site of Cheyenne. He arrived in Cheyenne in 1867 and worked as a freighter, a mail carrier between Fort Collins and Cheyenne, and operator of a livery business.

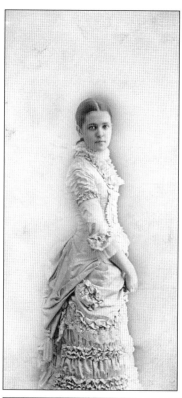

Louisa Swan Van Tassell as a Young Girl, c. 1875. In 1875, Van Tassell married Mary Moore, widow of wealthy rancher and freighting entrepreneur Jim Moore for whom Van Tassell worked. When Mary died in 1883, Van Tassell inherited her property and became a rich man. In 1886, he married 22-year-old Louisa Swan, daughter of cattle baron Alexander Swan. Swan had a house built, later known as Castle Dare, at Nineteenth Street and Carey Avenue for his daughter as a wedding present, but he could not afford to pay for it, most likely because of the cattle bust of 1886–1887, and the couple never lived there.

Castle Dare at 1920 Carey Avenue. Banker David Dare next bought the house but lost it when his bank, the Cheyenne National, failed. The contractor who constructed Castle Dare, R. W. Bradley, took the house over since his money was tied up in it. He and his family lived there for many years. The house was razed in 1964 and the carriage house demolished in 1993. (Stimson.)

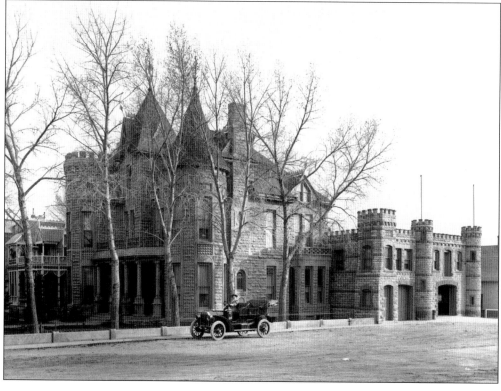

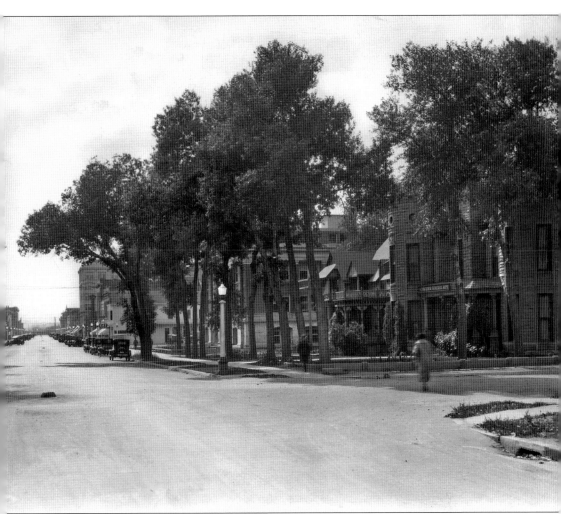

SCHRADER'S FUNERAL HOME (CASTLE DARE), C. 1925. Like many other mansions in cities all over the country, the biggest house in town often became a funeral home when the surrounding neighborhood began to decline or changed from residential to commercial or civic space. (Note the city/county building two doors down to the left of Castle Dare.) The large house became Schrader's Funeral Home in the 1920s. Schrader's eventually moved to the Max Idleman mansion and remains there today.

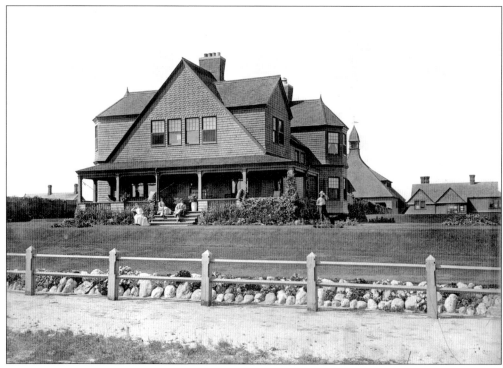

RENESSELAER S. VAN TASSELL HOUSE, 921 EAST SEVENTEENTH STREET. Designed by Cheyenne architect George Rainsford, the Van Tassell house stood on the lots where the current Casa Grande Apartments are located. The property included a large carriage house and a greenhouse. The carriage house was moved to Holliday Park and is home to the Cheyenne Artists Guild.

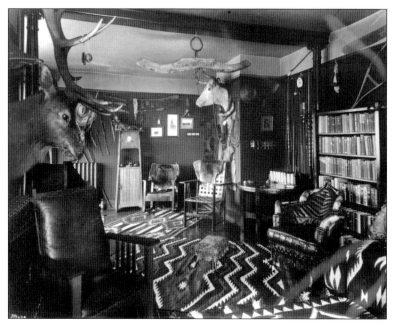

VAN TASSELL LIBRARY. Louisa Swan Van Tassell moved to Denver in 1908 and divorced Van Tassell in 1912. He married a third time, to Maude Bradley, who ironically had grown up in Castle Dare, the mansion built as a wedding present for Louisa Swan. The town of Van Tassell is named after Renesselaer S. Van Tassell. (Stimson.)

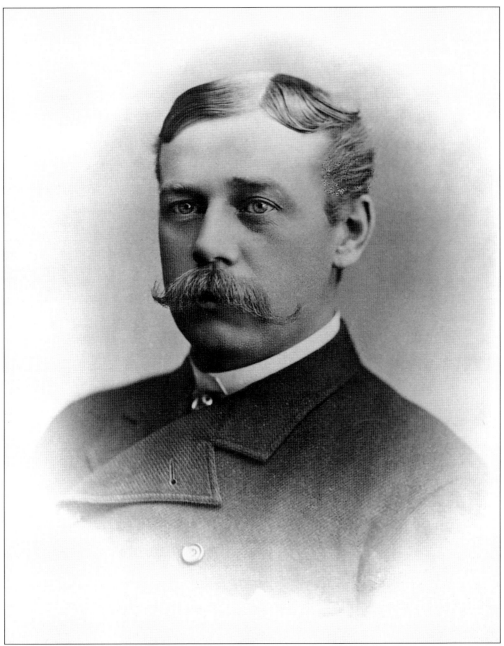

FRANCIS EMROY WARREN. A future Wyoming governor and U.S. senator, and one of the most influential men in the state, Warren was born in 1844 in Hinsdale, Massachusetts. Raised on his father's farm, Warren was industrious even as a child and became a farm manager by the age of 17. He served in the Civil War and headed west once the war ended. Amasa R. Converse, also raised in Hinsdale and living in Cheyenne by 1868, contacted Warren and urged him to join Converse there. Warren worked in Converse's furniture store, eventually joining him in a partnership and ultimately buying him out.

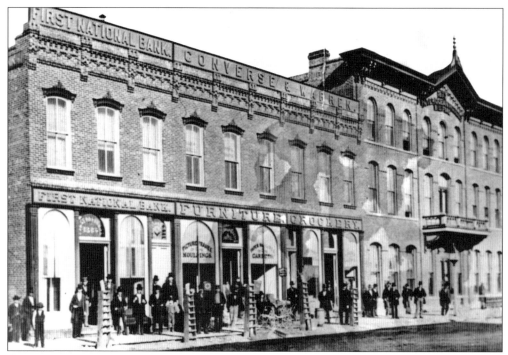

CONVERSE AND WARREN MERCANTILE, SIXTEENTH STREET BETWEEN CAPITOL AND CAREY AVENUES, 1878. Warren and Converse eventually partnered in the Converse and Warren Mercantile. Together they also started the Converse and Warren Livestock Company in the 1870s, which became the famous Warren Livestock Company. Converse founded the First National Bank, located next to the mercantile. Note the InterOcean Hotel to the right of the mercantile building.

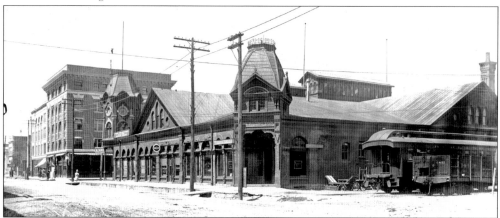

F. E. WARREN'S EMPORIUM, 1917, SOUTHEAST CORNER OF SIXTEENTH STREET AND CAPITOL AVENUE. The building housed the splendid Warren Emporium, built in 1884, which replaced F. E. Warren's mercantile building on Sixteenth Street next to the InterOcean Hotel. The largest retail structure in Cheyenne, the Emporium was a shopping haven for the city's wealthy women and featured furniture, carpets, glassware, and china as well as a ladies' lounge. The Emporium also catered to other women who could buy on credit. The company shipped its wares to far-flung towns in Wyoming and elsewhere. By 1889, the Burlington Depot occupied space in the building, which was demolished in the 1920s. (Stimson.)

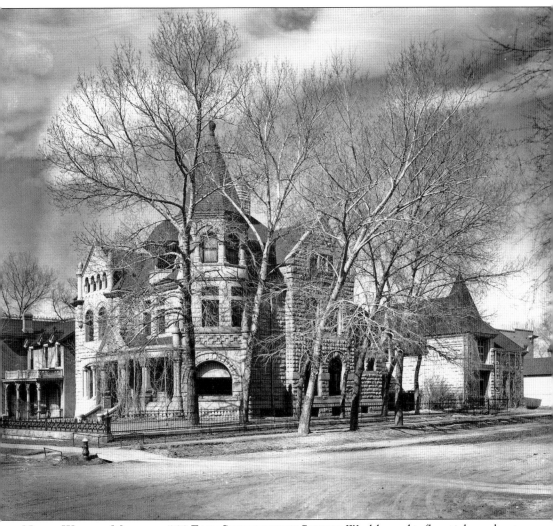

NAGLE-WARREN MANSION, 222 EAST SEVENTEENTH STREET. Wealthy and influential merchant Erasmus Nagle had the house constructed between 1886 and 1888. The opulent mansion featured parquet floors, stained-glass windows, cherry wood, oak and maple paneling, and three tin bathtubs surrounded in walnut. Francis E. Warren, who lived nearby, purchased the house in 1910 and spent his final years here. The house, built of sandstone rejected from the Capitol Building, was eventually sided with concrete when the stone began to crumble. It later became the YWCA and is now the Nagle-Warren Bed-and-Breakfast. (Stimson.)

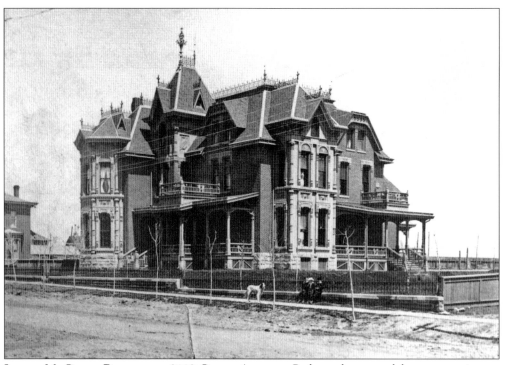

JOSEPH M. CAREY RESIDENCE, 2119 CAREY AVENUE. Perhaps the most elaborate mansion on Ferguson Avenue belonged to the Carey family. Born in Delaware in 1845, Joseph Carey came to Cheyenne in 1869 as U.S. attorney for the newly created Wyoming Territory. By 1876, he had closed his law practice in order to pursue his business interests and real estate in downtown Cheyenne. Carey later became one of Wyoming's two U.S. senators and also served one term as governor beginning in 1911.

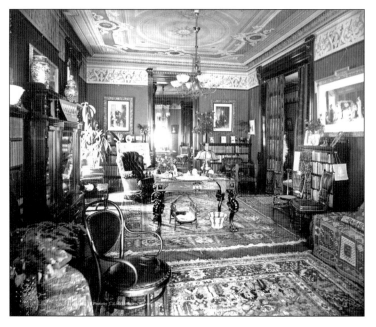

INTERIOR, JOSEPH M. CAREY HOUSE. Carey spared no expense in the construction of his new house in 1885. Lavish interior appointments included gold-embossed wallpaper, crystal chandeliers, large fireplaces, and parquet floors. The Careys were in the top echelon of Cheyenne society and often entertained at the ornate Victorian mansion, which served as the governor's mansion during Carey's term. (Stimson.)

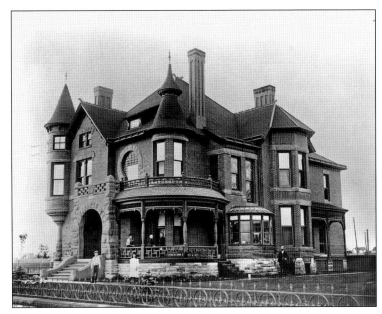

Max Idleman House, 2323 Carey Avenue. Idleman, a prominent merchant prince, made his fortune in the liquor and mercantile business in Cheyenne. The house is the only one remaining from Ferguson Street's glory days. It cost a reported $55,000 and featured a ballroom on the third floor and the Idleman's extensive art collection. It is now the Schrader Funeral Home.

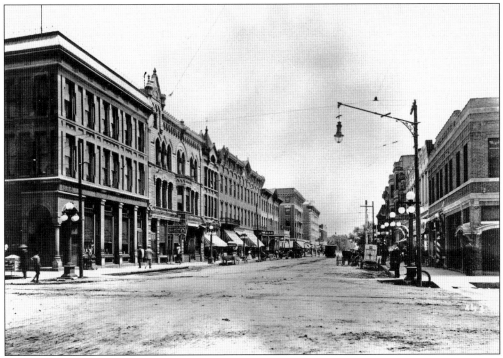

The Idleman Building, Northeast Corner of Sixteenth Street and Carey Avenue, c. 1911. Brothers Max and Abraham Idleman set up their wholesale liquor and cigar business in 1877 and by 1884 had built the Idleman Building on a prominent corner in downtown Cheyenne. A bar and gaming room occupied the back section of the building, with offices and apartments on the second and third floors. In the photograph, the Idleman Building is the one on the far left; next to it is the Commercial Building of 1883 and the First National Bank Building of 1882. All three buildings remain standing today.

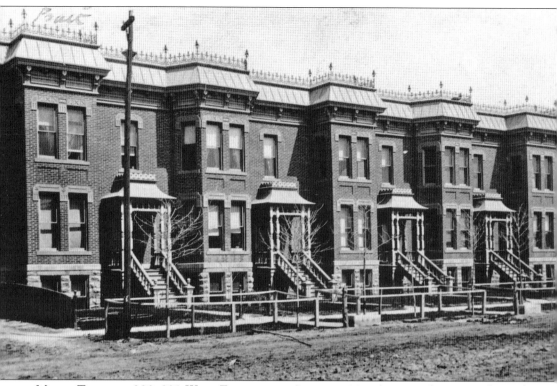

Maple Terrace, 200–220 West Eighteenth Street, 1883. A more urban type of upscale residence was built within the downtown. The fashionable Maple Terrace housed some of Cheyenne's wealthy bachelors and prominent families. The five townhouses included a kitchen and servants' quarters in the basement level, a dining room, library and parlor on the first floor, and bedrooms above. The First Presbyterian Church was built about the same time on the corner directly west of Maple Terrace.

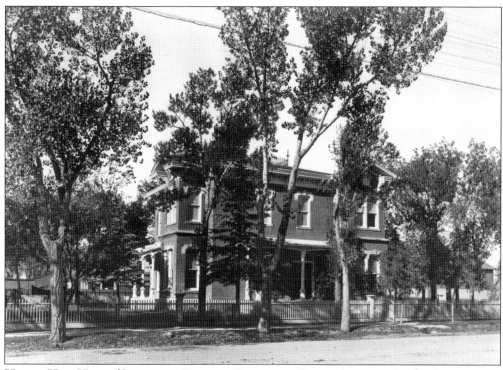

HENRY HAY HOUSE/CHEYENNE PRIVATE HOSPITAL, CAREY AVENUE. Banker Henry Hay's mansion had become a private hospital by 1906. By the early 20th century, private hospitals in former residences were common in many places across the United States. In 1867, the first hospital in the city consisted of a tent on Fifteenth Street. Two doctors, James Irwin and J. W. Graham, practiced there and then built a two-story frame structure on Carey Avenue with offices on the first floor and what became known as City Hospital on the second floor. A visitor to the hospital was appalled to find that two patients might share the same bed. The Union Pacific Railroad maintained a separate hospital, as did Fort D. A. Russell. (Stimson.)

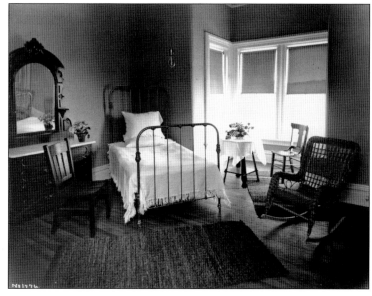

DORMITORY OF THE PRIVATE HOSPITAL, 1906. In 1882, the county established a hospital at Twenty-third Street between Evans Avenue and House Avenue, which they named St. John's Hospital of Laramie County. It later became the Laramie County Memorial Hospital and is now the Cheyenne Medical Center. (Stimson.)

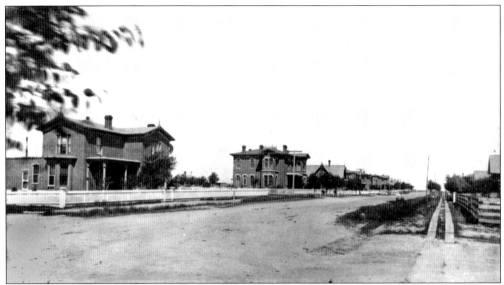

LOOKING NORTH ON CAREY AVENUE FROM TWENTIETH STREET. Carey Avenue, formerly Ferguson Avenue, was sometimes referred to as Millionaire's Row and is where Cheyenne's rich and famous built their residential showplaces in the 1880s. Lavish houses constructed in the ornate styles of the period reflected the owners' status and wealth. The wives and daughters of these families ruled local society and could often be seen at the Cheyenne Opera House. More than 30 large houses were built on Carey Avenue.

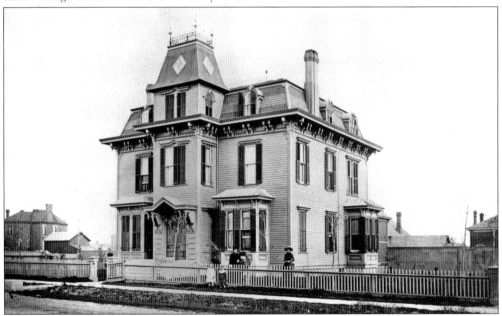

THE BRESNAHAN HOUSE, 201 EAST SEVENTEENTH STREET. Along with Carey Avenue, East Seventeenth Street became a fashionable address in the 1880s. Constructed in 1882 for rancher W. C. Irvine and then purchased by Mayor L. R. Bresnahan, the house stood across the street from the Cheyenne Club. Irish-born Bresnahan immigrated to America at the age of seven. He made his way to Cheyenne in 1867, established a meat market, and later became a five-term mayor of the city. His house was demolished in 1951. (Stimson.)

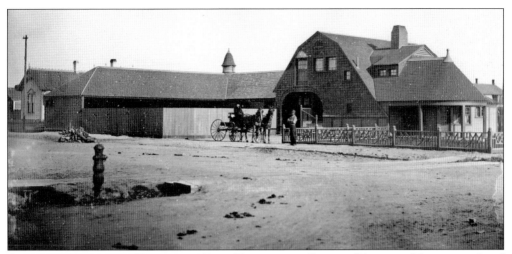

GEORGE D. RAINSFORD HOUSE, 704 EAST EIGHTEENTH STREET. "Eccentric," "enigmatic," and "quirky" were the words used to describe George Rainsford, who arrived in Wyoming in the early 1880s. He established the Diamond Ranch 12 miles west of Chugwater, where he bred and trained horses. By 1900, he had over 3,000 horses on his ranch. Rainsford grew up in a wealthy New York family and studied architecture in Europe. He also kept a house in town that he designed, still standing at 700 East Eighteenth Street. The unusual house had stables attached to it, and one could drive a carriage through an arched opening on the west side of the building. Although altered, the house remains at 702 East Eighteenth Street.

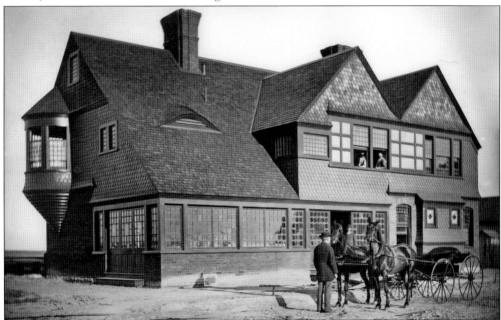

WILLIAM STURGIS HOUSE, 823 EAST SEVENTEENTH STREET. Rainsford designed this house for prominent cattleman William Sturgis. William and his brother Tom founded the large Union Cattle Company, which went under in 1886. Both brothers were charter members of the Cheyenne Club, another building designed by Rainsford. The Sturgis house is still standing. Rainsford's principle residence remained in Wyoming until about 1910, and he then spent summers in New York City and winters in Daytona Beach, Florida. He died there in 1935 at age 79.

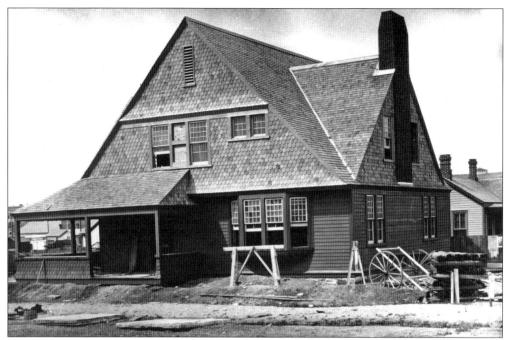

JUDGE CHARLES N. POTTER HOUSE, 1722 WARREN AVENUE. This Rainsford-designed house for Judge Potter displays some of the architect's signature elements: bay window, use of shingles, and steep roofline. Judge Potter arrived in Cheyenne in 1876 and served as Cheyenne's city attorney, the state's attorney general, and eventually as chief judge of the Wyoming Supreme Court.

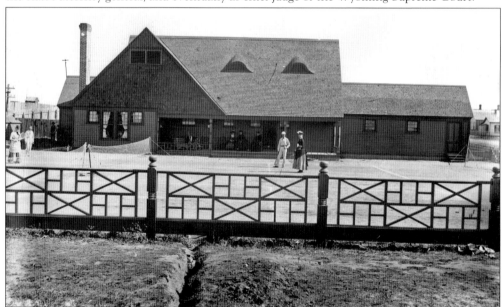

LAWN AND TENNIS CLUB, SIXTEENTH STREET BETWEEN PEBRICAN AVENUE AND RUSSELL AVENUE. Lawn tennis originated in England in the 1880s, and the sport soon became popular among wealthy easterners in the United States. Designed by architect George Rainsford and probably modeled after a clubhouse with which he was familiar back east, Cheyenne's private club became a popular spot for the city's young smart set. Tennis was also played just west of the Cheyenne Club.

Four

SCHOOL DAYS AND SUNDAYS

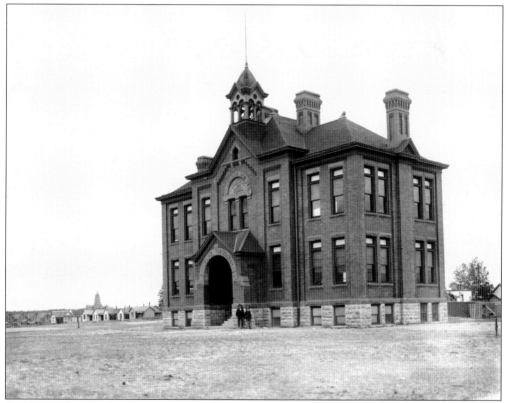

CONVERSE SCHOOL, TWENTIETH STREET AND PEBRICAN AVENUE. Cheyenne's east side school, constructed in 1882, was named after prominent Cheyenne pioneer Amasa Converse. Converse arrived in Cheyenne in 1867 and contacted his friend Frances E. Warren, who, like Converse, had grown up in Hinsdale, Massachusetts. Warren and Converse later became partners in the mercantile and ranching business until 1877. Converse helped organize and became president of the First National Bank. He twice served as treasurer of Wyoming Territory. Converse County and Converse Avenue in Cheyenne are named after him.

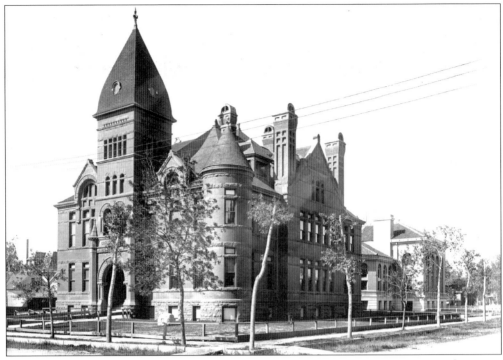

CHEYENNE HIGH SCHOOL, SOUTHWEST CORNER OF TWENTY-SECOND STREET AND CENTRAL AVENUE. Constructed in 1890–1891, the new Cheyenne High School included a library, chemistry lab, drafting room, and lecture hall in addition to the classrooms. Girls entered at the front door on Central while boys used the rear entrance. The Carnegie Library was just around the corner at Twenty-second Street and Capitol Avenue and is visible here. The building served as Cheyenne's secondary school until 1922, when a new high school was constructed at Warren Avenue and Twenty-eighth Street. The old school was demolished in 1964, and the site became a parking lot. (Stimson.)

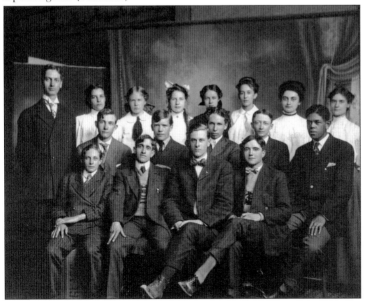

CHEYENNE HIGH SCHOOL GRADUATING CLASS, 1907. The senior class posed for a formal class picture in 1907. A high school education was not all that common at the turn of the 20th century, and many people ended their formal education upon completion of the eighth grade.

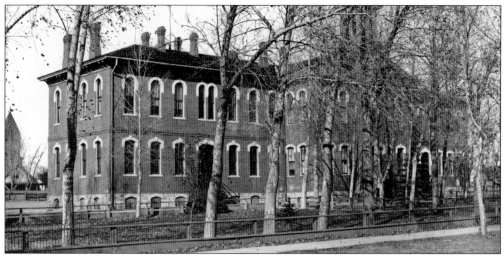

CENTRAL SCHOOL, WEST TWENTIETH STREET BETWEEN CENTRAL AND CAPITOL AVENUES. Two short months after the Union Pacific tracks reached Cheyenne, a frame public school building of two rooms had been constructed. It was in the block between Eighteenth and Nineteenth Streets and Carey and Pioneer Avenues. A two-story brick structure erected on Twentieth Street replaced the first school in 1871 and became known as Central School. The center section was constructed in 1876 and the west wing added in 1879–1880. The school accommodated grades 1 through 12 until the new high school was built in 1890. Eventually, a brick gymnasium occupied the north side of the block behind the school building. McCormick Junior High School, now the Emerson State Office Building, replaced Central School in 1928.

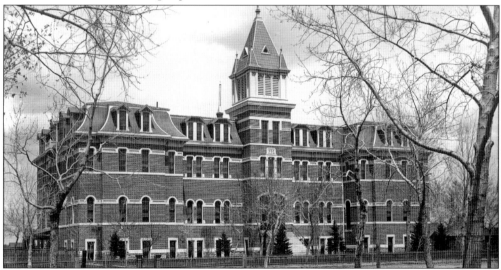

ACADEMY OF THE HOLY CHILD JESUS, NORTH SIDE OF TWENTY-FOURTH STREET BETWEEN CENTRAL AND WARREN AVENUES. The first Catholic school in Cheyenne opened in the former frame St. John's church building in 1884 and was known as St. John's. In 1886, the school moved to a large new brick building constructed by Moses Keefe one block east of the Capitol Building on the block bounded by Twenty-fourth and Twenty-fifth Streets and Central and Warren Avenues. The name changed to the Academy of the Holy Child Jesus and included a convent and accommodations for boarders from around Wyoming Territory. Gifts to the school included the tower bell from Keefe and the cross atop the tower from Harry Hynds.

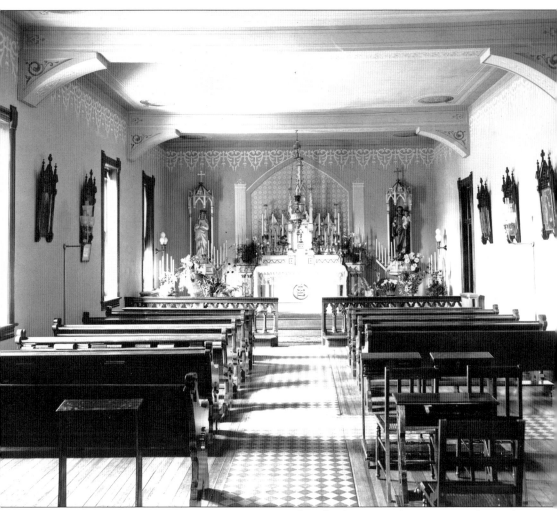

CONVENT CHAPEL OF THE HOLD CHILD JESUS. The school continued to operate as the academy until 1933, when the Society of the Holy Child Jesus withdrew their Sisters and the Dominican Order of Sisters took over. That same year, the school name changed to St. Mary's Academy. The academy had not functioned as a boarding school for many years, and a high school building was erected on a portion of the site in 1938. The old academy was renovated for an elementary school until a new one was constructed in 1952, at which time the academy building was demolished. (Stimson.)

SECOND BAPTIST CHURCH, WEST SIDE OF NINETEENTH STREET AND THOMES AVENUE, 1914. Ten African American members of the First Baptist Church established the Second Baptist Church in 1884. This brick building was constructed that same year. Rev. Z. T. Thistle, a recent arrival from Tennessee, became the first pastor. The building was demolished in 1922 after being condemned as unsafe. A new church was built on the site, and the building survives today although no longer as a church.

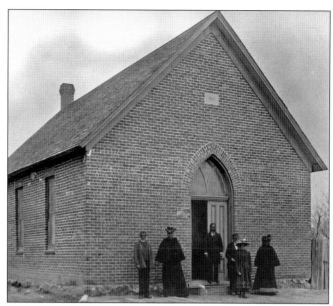

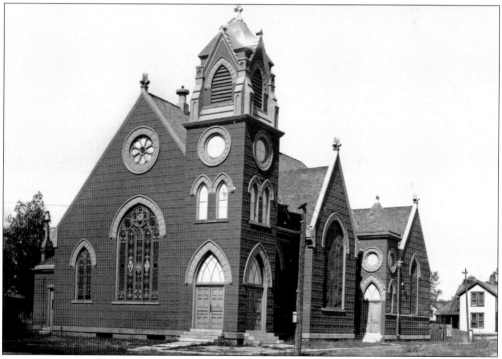

FIRST BAPTIST CHURCH, NORTHWEST CORNER OF NINETEENTH STREET AND WARREN AVENUE. Although a number of Cheyenne's churches were established by the late 1860s, the First Baptist Church was not organized until September 1877. The new church at the corner of Eighteenth Street and Carey Avenue, constructed in 1880–1881, proved to be unsafe by 1894, and another site was selected at Nineteenth Street and Warren Avenue. The second church officially opened in September 1894. The frame building was sided with metal that looked like pressed tin. Prominent members included I. C. Whipple, J. T. Holliday, S. A. Sturgis, and Miranda Crook, the wife of Dr. W. W. Crook. The church relocated to 1800 East Pershing Boulevard in 1955.

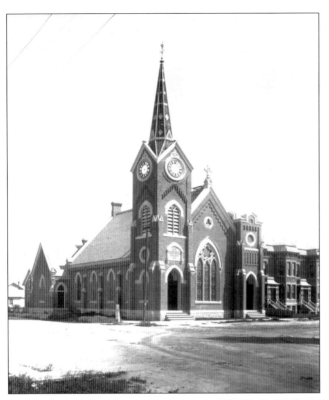

First Presbyterian Church, Twenty-second Street and Carey Avenue, 1881. The Union Pacific Railroad, as it did with other denominations in Cheyenne, donated the lot on which the first frame church building was constructed at Eighteenth Street and Carey Avenue in 1870. In 1884, dedication of a new substantial brick-and-stone building took place. The hands of the imitation clock rested at 11:20, the exact time Abraham Lincoln was shot. Eighteenth Street and Carey Avenue became known as "church corner" at this time since the Baptist and Episcopal churches were located on two of the other corners. The building was razed in 1925. Note Maple Terrace to the right of the church.

First Congregational Church, Northwest Corner of Nineteenth Street and Capitol Avenue. The Cheyenne church organized in 1869 and located its first building on a lot donated by the Union Pacific Railroad. This brick building replaced the 1869 frame structure in 1883–1884. It was the first church in Cheyenne to have electricity installed while in the construction phase. In 1954, the church decided to relocate to the suburbs, and the leaded-glass windows were moved to the new building. The 1884 building was eventually demolished.

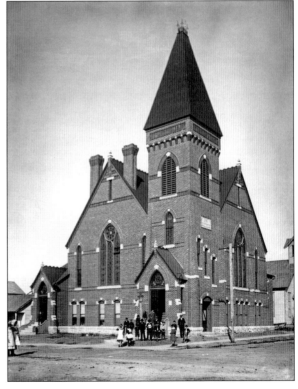

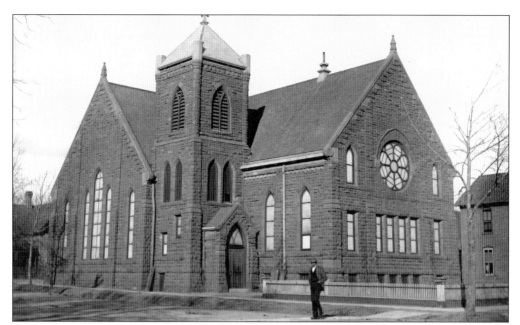

FIRST METHODIST CHURCH, NORTHEAST CORNER OF EIGHTEENTH STREET AND CENTRAL AVENUE. The first Methodist service was held on September 29, 1867, two months before the railroad reached Cheyenne. A frame church building was constructed in 1870 at Eighteenth Street and Central Avenue on land acquired from the Union Pacific Railroad. Plans to erect a new church began in 1889. Cheyenne's premier contractor, Moses Keefe, used red sandstone from Iron Mountain and brick from his new brick factory in Cheyenne. James P. Julien, a local architect, designed the building that was dedicated in 1894.

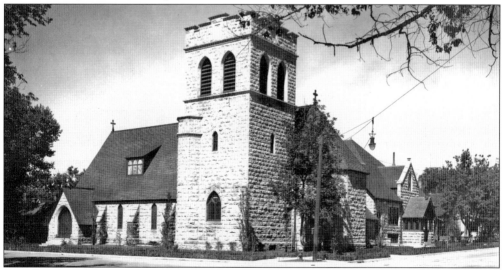

ST. MARK'S EPISCOPAL CHURCH, NINETEENTH STREET AND CENTRAL AVENUE. St. Mark's Episcopal Church in Philadelphia donated $1,000 for a new church in Cheyenne. Named after that church, Cheyenne's St. Mark's was organized in early 1868 and a church building constructed on two lots donated by the Union Pacific Railroad. The cornerstone of a new church at Nineteenth Street and Central Avenue was laid in 1886, although construction was not completed until 1893, due in part to financial constraints following the bust of the cattle industry in 1887. (Stimson.)

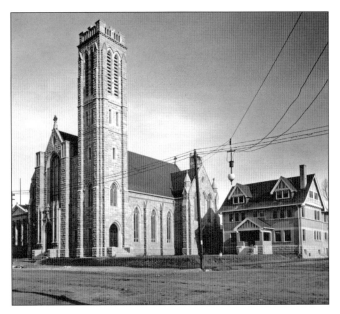

ST. MARY'S CATHOLIC CATHEDRAL AND THE BISHOP'S HOUSE, 1910. The Union Pacific Railroad donated the land at the northeast corner of Twenty-first Street and O'Neil Avenue upon which the first Catholic church, known as St. John's, was constructed in 1868. As the church grew, so did the need for a new building, erected at the northeast corner of Nineteenth Street and Carey Avenue in 1879. This was the first brick church in Cheyenne. The Diocese of Cheyenne was created in 1887, and the name changed to St. Mary's. (Stimson.)

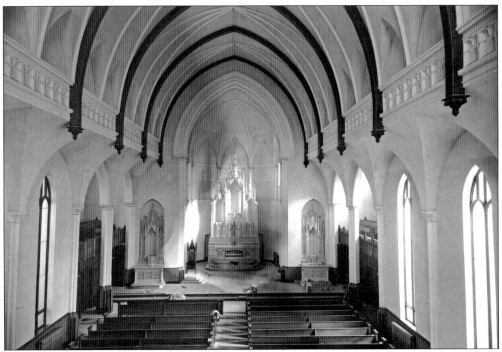

INTERIOR, ST. MARY'S CATHEDRAL, 1908. The next major change occurred in the early 1900s when the search began for a suitable site for a cathedral. The cornerstone of the new building, at the northeast corner of Twenty-first Street and Capitol Avenue, was laid on January 7, 1907, and the cathedral was consecrated in 1909. Moses P. Keefe constructed the building of native sandstone from his quarry west of Cheyenne at Iron Mountain. Highlights of the interior included stained-glass windows made in Europe, oak trim and pews, and an organ purchased with money donated by Andrew Carnegie. The sanctuary received a facelift in the early 1980s in accordance with a Vatican II decree. (Stimson.)

Five

FORT D. A. RUSSELL

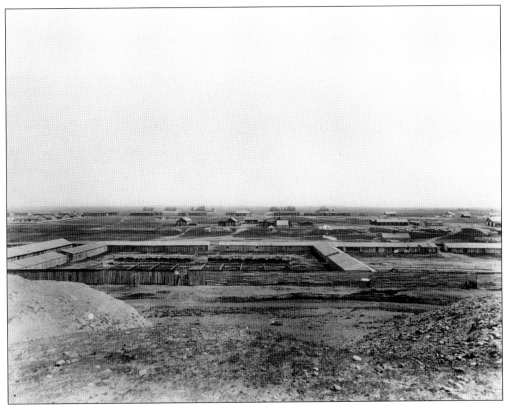

CAMP CARLIN, 1884. Camp Carlin, approximately 1.5 miles north of Cheyenne, was constructed in August 1867, simultaneously with nearby Fort D. A. Russell. It was the largest military supply depot west of the Mississippi River. Equipment, weapons, and other supplies were shipped to Camp Carlin by the Union Pacific Railroad and then freighted to 12 army forts on the frontier, some as far as 500 miles from Cheyenne. The camp employed hundreds of men as packers, wheelwrights, blacksmiths, engineers, herders, teamsters, watchmen, laborers, and clerks. Numerous warehouses and corrals were built at the camp, which at one time used over 3,000 horses and mules and 100 wagons. Camp Carlin operated until 1890, when the army closed the depot. Some of the buildings at the camp were moved into Cheyenne.

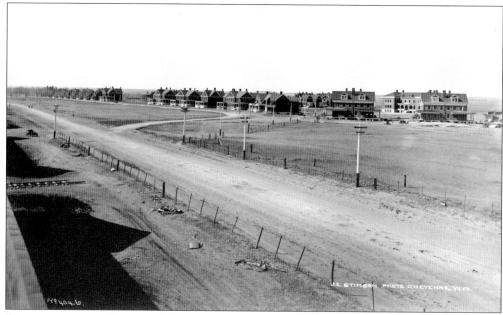

CONSTRUCTION OF OFFICERS' HOUSES, 1904–1908. The first housing at Fort D. A. Russell in 1867 was temporary log huts for the enlisted men and tents for the officers. Construction of frame barracks and officers' quarters was completed by spring or summer of 1868. By the end of that year, there were at least 77 permanent wooden buildings surrounding a diamond-shaped parade ground. None of those buildings survive today. (Stimson.)

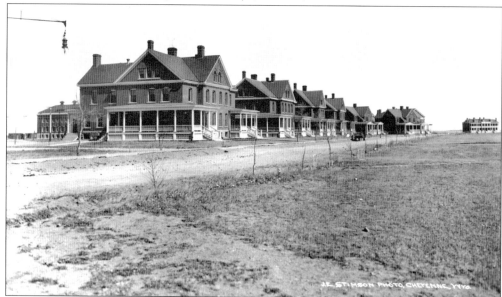

OFFICERS' HOUSES. Between 1885 and 1900, brick became the primary building material for new barracks and officers' quarters, although others were frame. Thirteen frame buildings remain from that period; others were moved into Cheyenne to be used as residences. The most ambitious building program at the fort took place between 1900 and 1913 when the officers' houses in the photograph were constructed, along with nearly 150 more structures. The large building programs employed many civilians from Cheyenne. (Stimson.)

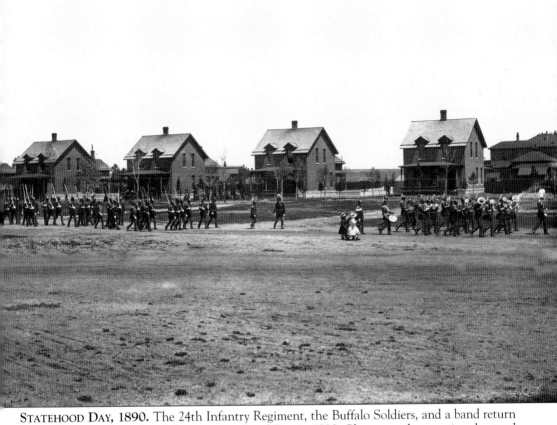

STATEHOOD DAY, 1890. The 24th Infantry Regiment, the Buffalo Soldiers, and a band return from a downtown parade celebrating Statehood Day in 1890. Cheyenne always enjoyed a good relationship with the nearby military post. The elite officers socialized with Cheyenne's upper-crust society, who attended balls and receptions at Fort D. A. Russell. Cheyenne residents enjoyed the military maneuvers at the fort and often came to watch. The fort's fire crew aided the city companies when the large fires of the 1870s threatened to level downtown Cheyenne. Both the fort and the city had baseball and football teams that played against each other in fierce competitions. The cannons at Fort D. A. Russell kicked off the first Frontier Day at exactly noon along with church bells and railroad whistles.

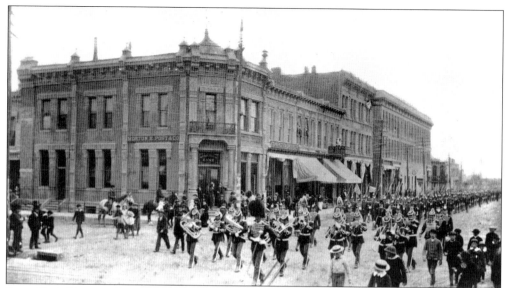

FORT D. A. RUSSELL BAND, SEVENTEENTH STREET AND CAREY AVENUE, C. 1886. Downtown parade routes often headed north on Carey Avenue. The Fort D. A. Russell and other local bands were a popular form of entertainment in Cheyenne at the time and were usually featured in parades. In the photograph, the Tufty Band, led by a drum major, marches north at the southeast corner of Seventeenth and Ferguson Streets in front of the Kent Building. Behind them are soldiers from the fort. The Idleman Block is the building on the left at the corner of Sixteenth Street and Carey Avenue.

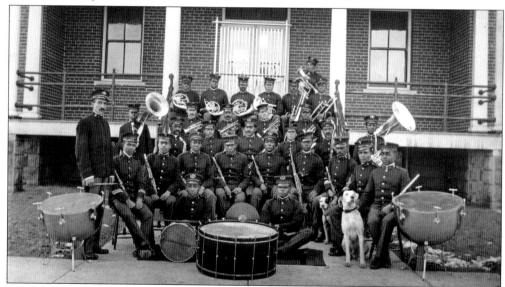

MEMBERS OF A MILITARY BAND AT FORT D. A. RUSSELL, 1895–1900. A band had been part of the military contingent since the first days at Fort D. A. Russell, and the members shared the same quarters. The band played at both formal military ceremonies and more casual concerts at the fort, at which the citizens of Cheyenne were welcome. A band from Fort D. A. Russell played at Cheyenne's first Fourth of July celebration in 1869 and led the parade. The fort's 3rd Cavalry string orchestra provided dance music at the inaugural ball and banquet for the opening of the Cheyenne Opera House.

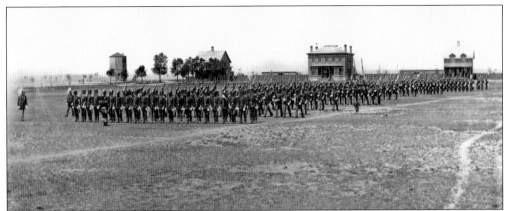

FORT D. A. RUSSELL, 24TH INFANTRY DRILLING ON PARADE GROUND, C. 1898. Cheyenne's history is directly linked to the Union Pacific Railroad and Fort David A. Russell, now known as F. E. Warren Air Force Base. The Railroad Act of 1862, which chartered the Union Pacific Railroad, also included provisions for a military base and town to be established at the eastern foot of the Rocky Mountains. In fact, the sites of the future fort and the town of Cheyenne were selected the same day, July 4, 1867. The fort was named after Gen. David A. Russell, who died in the Civil War at the Battle at Opequan, Virginia. The primary purpose of the new fort was to protect railroad workers as they constructed the Union Pacific tracks westward toward Cheyenne. A secondary assignment was to preserve law and order in the new town of Cheyenne until civil authority could be established. The presence of the nearby fort helped Cheyenne's economy, as supplies were often purchased from the local merchants. Between 1870 and 1880, the fort brought more than 1,000 men into Wyoming Territory who often headed to Cheyenne when payday arrived.

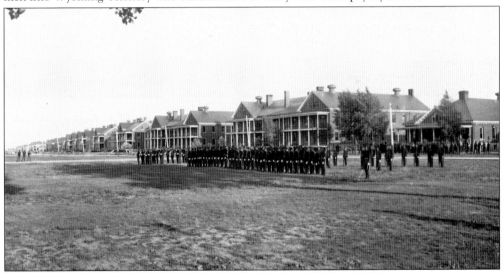

GUARD MOUNT AND ENLISTED MENS' QUARTERS, 1910. In the early 1900s, Congress reorganized the military and limited the number of armed forces to 60,000 men, which meant a number of forts would be closed. Thanks to the influence of Wyoming's Sen. Francis E. Warren, the Cheyenne fort not only became a permanent installation but its status changed to a brigade post. New cavalry and artillery barracks like those in the photograph were part of the expansion. As the fort grew eastward toward Cheyenne, new parade grounds were created. In 1930, the name of Fort D. A. Russell changed to Fort Francis E. Warren to honor him and his contribution to the nation, state, and the fort. (Stimson.)

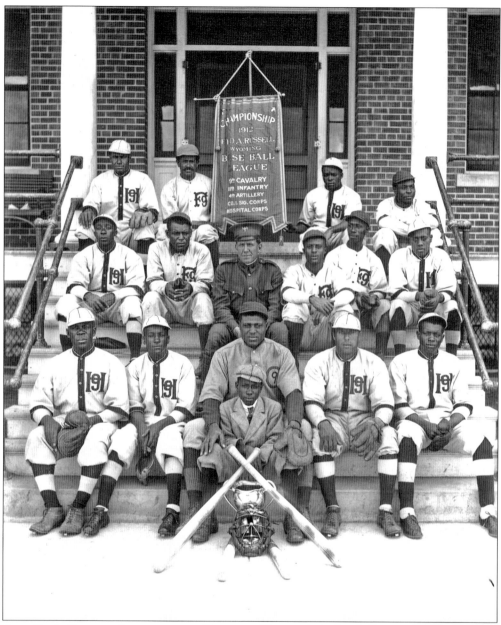

FORT D. A. RUSSELL CHAMPIONSHIP BASEBALL TEAM, 1912. Baseball was a popular game in Cheyenne and at the fort. An early Cheyenne team known as "Eclipse" played teams from Fort Russell in front of crowds of 200 and 300 people. The movement of troops during the Civil War, and afterward to the frontier, helped spread the game of baseball to the West.

Six
BIG FISH IN A SMALL TOWN

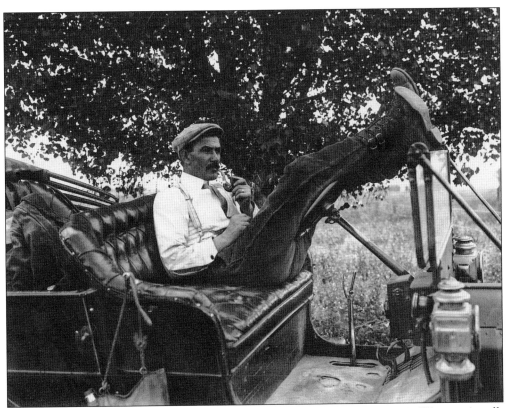

JOSEPH STIMSON IN HIS FORD WITH FAVORITE MEERSCHAUM PIPE, C. 1910. Wyoming's well-known photographer Joseph Elam Stimson was born in 1870 in Virginia and raised in rural South Carolina. He apprenticed with a professional photographer, his cousin James Stimson, in Appleton, Wisconsin, for three years before making his way to Cheyenne in 1889. He bought photographer Charles Kirkland's equipment and studio at 1717 Capital Avenue and began his career as a portrait photographer. Stimson photographed many of Cheyenne's residents during this period, but most of those glass-plate portraits were lost in the 1930s. (Stimson.)

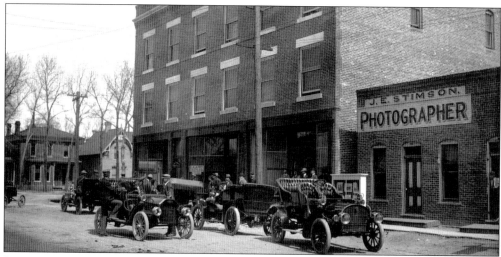

STIMSON STUDIO AT 1717 CAPITOL AVENUE, 1906. Stimson and his wife, Anna Patterson Stimson, lived in an apartment building next door to his studio for a few years before he bought a modest William Dubois–designed house on Twenty-fifth Street across from the Wyoming State Capitol. Stimson's studio on Capitol Avenue was located in the same block as the Alert Fire Company and the Stock Growers National Bank. Stimson became much more than a Cheyenne photographer when he began working for the Union Pacific Railroad, recording towns, businesses, and scenery along the main line through the Midwest and West. Despite his growing reputation and acclaim, Stimson continued to live and work in Cheyenne, where he photographed many of the city's buildings and people over the 60-year span of his remarkable career. (Stimson.)

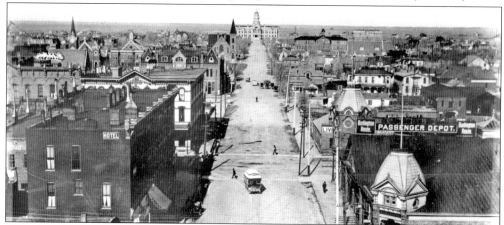

CAPITOL AVENUE FROM THE UNION PACIFIC RAILROAD, 1890. This view from the tower of the Union Pacific Railroad Depot is an emblematic Stimson shot. He took many images from the depot. The streetcar in the foreground is ready to turn west onto Sixteenth Street. A group of local businessmen formed the Cheyenne Street Railroad Company in 1887. The Cheyenne Carriage Works furnished the cars, which ran on three separate routes: one to the fairgrounds at Pioneer Park, northwest of the city; another on Nineteenth Street east to Russell Avenue; and a third to the Capitol Building and the cemetery to the east. The first viaduct across the Union Pacific rails was constructed in 1889, which allowed the streetcar system to expand southward as that part of town grew. To the left in the photograph looking toward the capitol are the Normandie Hotel, the InterOcean Hotel (which fronts on Sixteenth Street), and the Cheyenne Opera House on the corner of Seventeenth Street. (Stimson.)

HARRY P. HYNDS. One of Cheyenne's most successful businessmen of the late 19th century and well into the 20th century was Harry Patrick Hynds. He was born in Illinois in 1860 and learned the blacksmith trade there. He made it to Cheyenne by 1882 and worked at his trade for a number of years until he went into the saloon business at 2004 Pioneer Street in 1885, competing in prizefights along the way. In 1888, he established the Capitol Saloon at 1610 Carey Avenue. An inveterate gambler, Hynds ran an upscale gambling hall on the second floor above the saloon. Hynds shot and killed his wife's lover, Walter Dinwoody, in 1886 in Salt Lake City but managed to escape prison time.

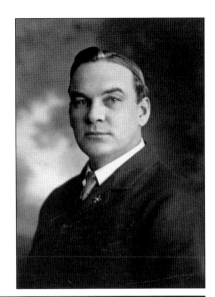

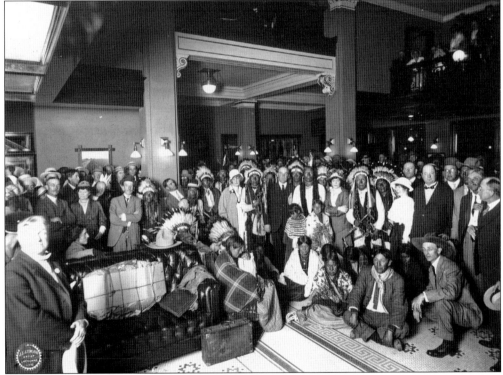

HARRY HYNDS AND NATIVE AMERICANS AT THE PLAINS HOTEL, AUGUST 19, 1914. When the Plains Hotel opened in 1911, Hynds (center) and a partner leased the hotel and operated it. Under Hynds's experienced management, the Plains became a first-rate hotel. He also bought the InterOcean Hotel around the same time and ran it until 1916, when the building was leveled by a fire. Hynds died in 1933; his funeral at St. Mary's Cathedral was one of the largest ever held in the city. Cheyenne benefited in many ways from his generosity to organizations as well as individuals in need. His legacy lives on in the Hynds Building in downtown Cheyenne and the Hynds Lodge, west of Cheyenne, which he had built for the Boy Scouts. (Stimson.)

MOSES P. KEEFE. Often named as contractor of some of Cheyenne's most prominent buildings, Keefe was born in Ireland in 1853 and immigrated to America in 1870. He lived in various places—Chicago, Deadwood, and Leadville, Colorado—and finally landed in Cheyenne in 1879 where he operated a contracting business. He worked on the construction of Cheyenne's new water system in 1884–1885 and became involved in politics around the same time. He served in the Ninth Territorial Legislative Assembly, as a member of the Cheyenne City Council, as Laramie County commissioner, and mayor of Cheyenne. He built both wings of the new State Capitol Building in 1888–1889.

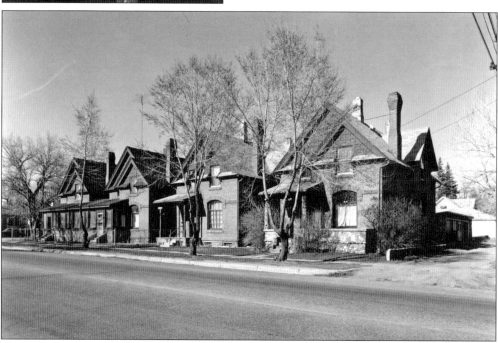

KEEFE COTTAGES, 2115–2121 EVANS AVENUE. Keefe constructed more than just monumental buildings like the state capitol and St. Mary's Cathedral. He also constructed houses for Cheyenne's elite as well as the more modest Keefe Cottages, built in 1900 and remaining today. He had contracts with the military and built numerous structures at Fort D. A. Russell, Fort Crook near Omaha, Fort Meade in South Dakota, and Fort Robinson in Nebraska. Keefe had his own quarries, brick, and stone yards, and in 1914, he established the National Lumber and Mill Company in Cheyenne. Keefe died in 1929 and is buried in Lakeview Cemetery.

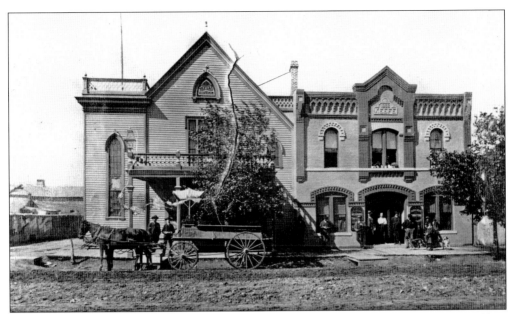

THE FIRST KEEFE HALL, 1814–1816 CAREY AVENUE. Keefe built the first Keefe Hall, the building on the right, in 1888. The building on the left was an old church that Keefe moved to become part of Keefe Hall. Over the years, the large hall accommodated dances, parties, roller skating, and Cheyenne High School girls' basketball games.

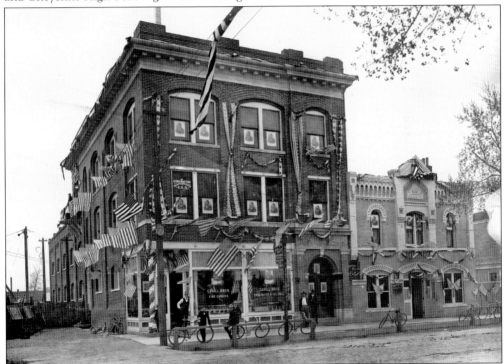

THE SECOND KEEFE HALL, 1814–1816 CAREY AVENUE. Keefe eventually demolished the former church building and constructed this much larger hall on the corner, which housed offices. Both Keefe buildings are decorated for one of F. E. Warren's political campaigns. (Stimson.)

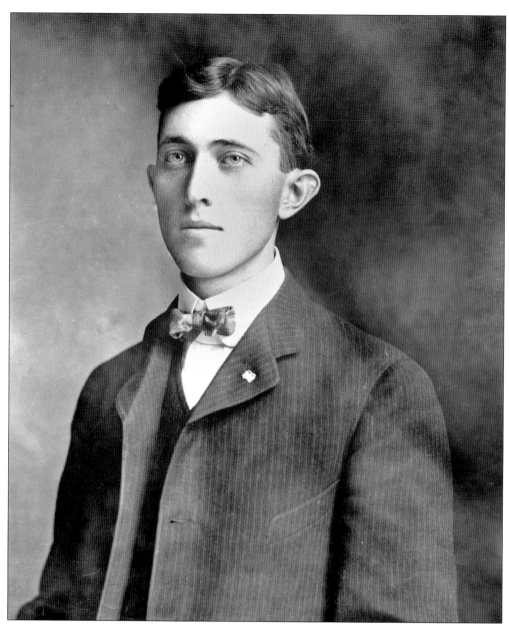

ARCHITECT WILLIAM DUBOIS. Wyoming's premier architect, William R. Dubois, came to Cheyenne from his native Chicago in 1902 when he was 22 years old. His first job in the city was to supervise construction of the Carnegie Library. Dubois became a prominent citizen of Cheyenne, serving twice as president of the Industrial Club, forerunner of the chamber of commerce, and as a member of the Wyoming State House and Senate for 10 years. He married the daughter of newspaper editor and Frontier Days cofounder E. A. Slack. Dubois designed many of Cheyenne's large buildings, including the Plains Hotel, the Elks Club, the Supreme Court Building, and numerous schools and residences. He also practiced throughout the state and was the architect of the University of Wyoming's Half Acre Gym and Arts and Sciences Building, the Elks Club in Rawlins, and homes in Douglas. His grandson, William R. Dubois, resides in Cheyenne and is a well-known historian and author. (Stimson.)

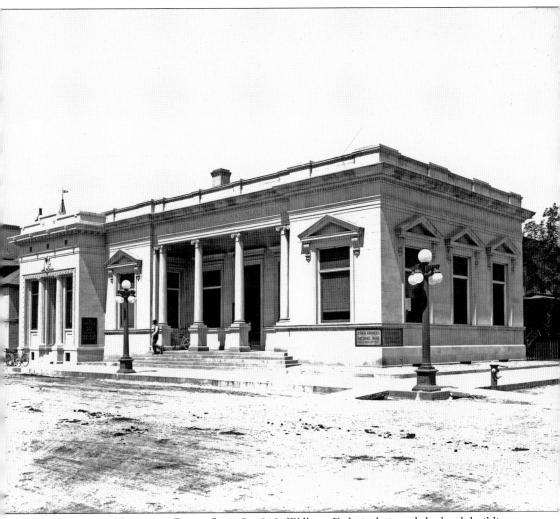

STOCK GROWERS NATIONAL BANK, JULY 7, 1910. William Dubois designed the bank building. The Stock Growers National Bank was founded by Joseph M. Carey, Henry Hay, and Tom Sturgis and first opened its doors in 1882 in the Carey Block, located on Seventeenth Street between Carey and Pioneer Avenues. The bank then moved to its own building on the northeast corner of Seventeenth and Capitol Avenue, in 1906. The bank was completely remodeled in 1961 and became the First National Bank and Trust Company of Wyoming. (Stimson.)

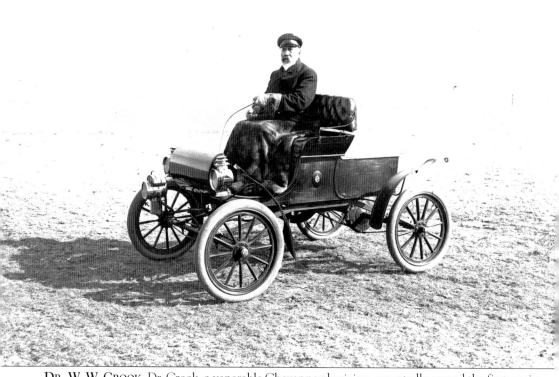

Dr. W. W. Crook. Dr. Crook, a venerable Cheyenne physician, reportedly owned the first car in Cheyenne, an Oldsmobile. Crook's wife, Miranda, and daughter Fannie were active in Cheyenne society. His house is located at 314 West Twenty-second Street and is part of the Rainsford National Register Historic District, named after Cheyenne architect George Rainsford. (Stimson.)

Seven
OUT AND ABOUT

EIGHTEENTH STREET LOOKING WEST BETWEEN CAPITOL AND CENTRAL AVENUES. This residential area was one block north of downtown. The gabled house was Gov. Thomas Moonlight's house and is at the present site of Cheyenne Light, Fuel, and Power Building. It became the Gables Tea Room. The first house on the right became a boardinghouse. Maple Terrace is barely visible one block west of these houses.

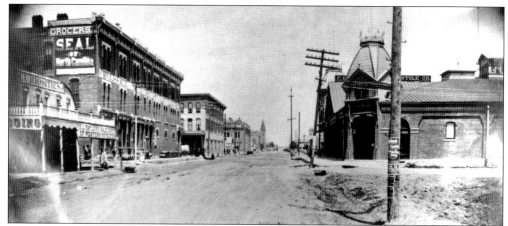

LOOKING NORTH ON CAPITOL AVENUE FROM FIFTEENTH STREET, C. 1885. This is a rare view of Capitol Avenue before the Capitol Building was constructed in 1887. It is not clear from the photograph if the new Union Pacific Depot had been built yet. F. E. Warren's new mercantile building, constructed in 1885, is on the right. The Normandie Hotel on the left was built in 1882. The InterOcean Hotel is just north of the Normandie, and behind that is the Cheyenne Opera House. The tower of the First Congregational Church, on the northwest corner of Nineteenth Street, is seen in the distance on the left. A building from Cheyenne's early days stands on the immediate left. Advertising "Curiosities," the pre-1872 building contained lodging rooms, the English House Lunch Room, and G. L. Taylor's Sale Depot of Western Novelties. The Albany Hotel replaced this structure. (Stimson.)

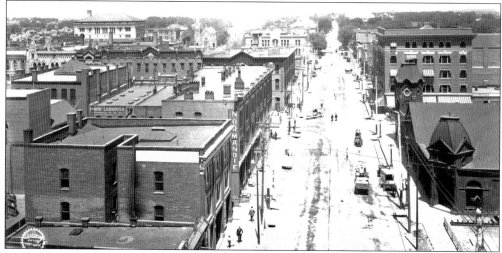

LOOKING NORTH ALONG CAPITOL AVENUE FROM THE UNION PACIFIC DEPOT, C. 1908. This is one of Joseph Stimson's numerous photographs from the vantage point of the depot tower. F. E. Warren's Emporium Building of the 1880s is on the right and by this time served as the Burlington Railroad Depot. The InterOcean Hotel and the Warren Block beside it are visible just north of the Normandie Hotel. The opera house is the large three-story building behind the InterOcean. The new post office building, across from the First Presbyterian Church, is the large, hipped-roof building at the top left. The prominent buildings of the 1870s and 1880s are beginning to look old-fashioned compared to the post office building and the new office building on the northeast corner of Sixteenth Street and Capitol Avenue. Street trees planted 30 years earlier define the more residential areas. (Stimson.)

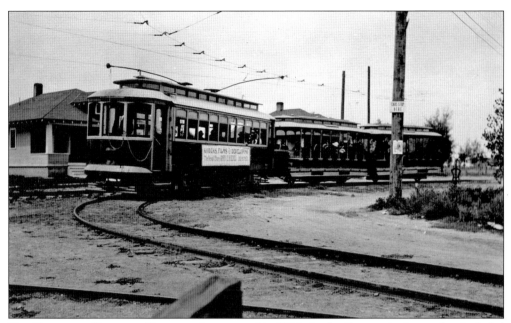

THE CHEYENNE ELECTRIC RAILWAY. Inaugurated in 1908, the 5-mile route had stops that included the Union Pacific Depot, other downtown locations, residential areas, and Lake Minnehaha, with a branch line to the new Frontier Park north of the city. The advent of the automobile and the Cheyenne Motor Bus Company made the railway obsolete. Note the advertising for Andy Roedel's drugstore on the side of the car. Roedel's Drugstore was located in the Knights of Pythias Building.

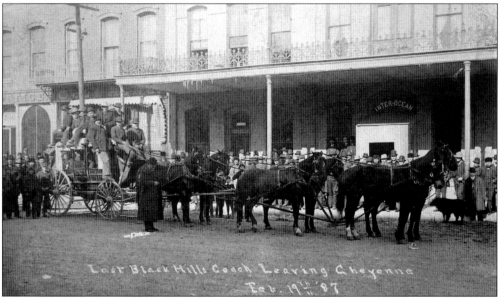

LAST BLACK HILLS STAGE LEAVING CHEYENNE, FEBRUARY 19, 1887. The Cheyenne and Black Hills Stages departed from the InterOcean Hotel, which is the building behind the horses in the photograph, between 1876 and 1887. Thousands of gold seekers poured into Cheyenne and took the stage to the Black Hills. Riding or driving the stage could be dangerous, as road agents and Native Americans might attack and drivers were sometimes killed. When a railroad finally reached the Black Hills, the Cheyenne and Black Hills Stage Company became history.

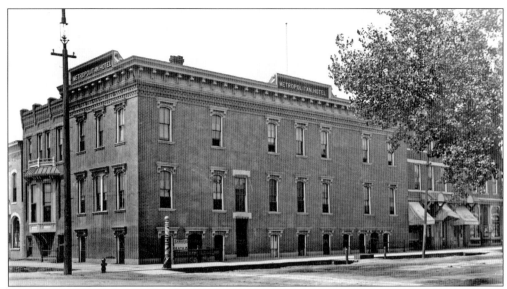

THE METROPOLITAN HOTEL, NORTHWEST CORNER OF FIFTEENTH STREET AND CAREY AVENUE. Located directly across Fifteenth Street from the Union Pacific freight depot, the Metropolitan Hotel advertised in the 1895 city directory: "We Strive To Please. . . . The home of the Traveling Man, the Mechanic, the Merchant, the Statesman and the Ranchman . . . Special Rates By The Month." The ground floor featured a Turkish bath, barbershop, and a restaurant. Other businesses on the same block of Fifteenth Street included a pool hall, two saloons, a bakery, two confectioneries, and two dwellings.

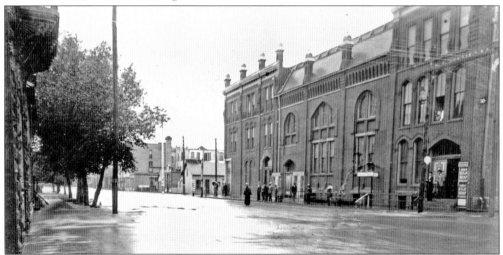

FLOOD OF 1896, CAPITAL AVENUE. This flood occurred on July 15, 1896. The Cheyenne Opera House is the large building in the center of the photograph. Heavy summer rains could cause Crow Creek to overflow its banks and create flood conditions. Water also ran downhill from the higher areas north of Cheyenne and headed straight for downtown. Thousands of dollars' worth of merchandise stored in basements would be lost. The floods that occurred over the years destroyed bridges across Crow Creek to the west, and houses south of the Union Pacific tracks floated away. The 1883–1884 construction of the Talbot Ditch north of the city helped to channel water to Crow Creek rather than downtown and alleviated some, but not all, flooding in later years. (Stimson.)

Eight

WHEN GIANTS RULED THE EARTH

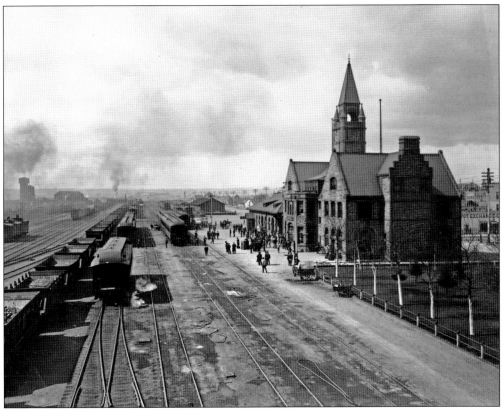

UNION PACIFIC DEPOT LOOKING WEST, 1906. The influence of the Union Pacific Railroad on Cheyenne's history and economy cannot be disputed. At one time, the railroad employed over 2,500 people in the city. By the early 1900s, the UP yards were a bustling place with passenger trains coming and going and long freight trains passing through. To the west, the city ended abruptly at the prairie. The Union Pacific Park is visible on the right on land where the large 1922 addition to the depot now sits. The railroad included park space at its larger depots along the main line, and the one in Laramie still exists today. (Stimson.)

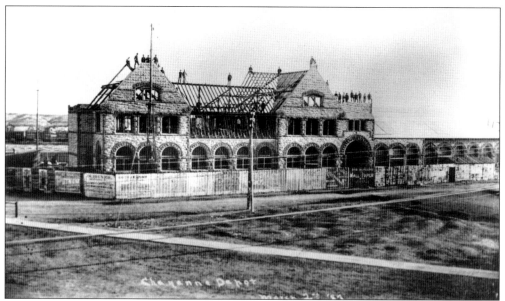

THE UNION PACIFIC DEPOT UNDER CONSTRUCTION, 1887. By the 1880s, Cheyenne's downtown had three-story brick and stone buildings, but the nearby depot was still a small frame structure. Civic leaders lobbied the Union Pacific Railroad for a depot more becoming Cheyenne's status as an important city along the UP's main line. In 1885, the railroad finally agreed to erect a substantial red sandstone depot for a cost of $100,000. A workforce of 70, including 20 stonemasons, worked on the building, which was completed in November 1887.

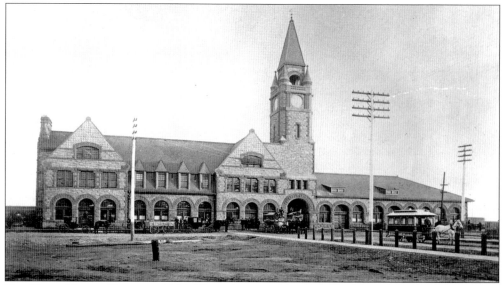

THE UNION PACIFIC DEPOT, C. 1890. The architectural firm of Van Brunt and Howe of Kansas City designed the two-story Richardsonian Romanesque–style depot, which cost $100,000. Cheyenne's two most impressive buildings, representing the two most powerful entities in the city, the depot and the new Capitol Building, faced each other at opposite ends of Capitol Avenue. The depot's tower could be seen from all over the city and symbolized the power of the mighty railroad. The horse-drawn streetcar, stagecoach, and waiting carriages indicate lots of activity at the depot. Van Brunt and Howe also designed the depots at Ogden, Utah, and Omaha for the Union Pacific.

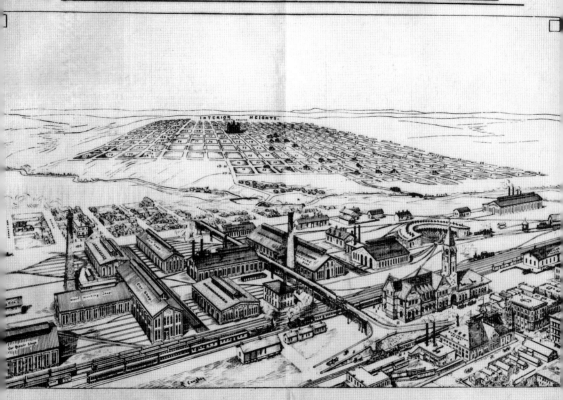

THE INTERIOR LAND AND IMMIGRATION COMPANY, C. 1889. The illustration advertises a land developer's ambitious dream for Cheyenne's south side, named Interior Heights. The 250-square-block development was based on the Union Pacific's expansion of the railroad yards in 1890. Advertising for the development read, "Interior Heights is admirably located to furnish homes for the rapidly increasing shop forces." Two of the railroad shops shown in the drawing were never constructed, nor was Interior Heights. The viaduct was new in 1890.

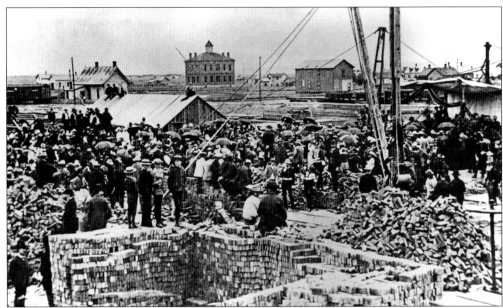

LAYING THE CORNERSTONE OF THE UNION PACIFIC SHOPS, JULY 10, 1889. Although Cheyenne had been a division point along the Union Pacific line, few buildings other than a stone roundhouse, machine shop, and blacksmith shop were constructed in 1868. In 1889, the railroad began a massive building project that included a new machine shop, blacksmith shop, paint shop, tank shop, and car shop. The large building in the center background is the Southside School. The structure with flared eaves and two chimneys to the left of the school is the 1870s Denver Pacific Railroad Depot, which was moved to 316 East Tenth Street and is a residence today. The cornerstone of the machine shop is displayed in the Cheyenne Depot Museum.

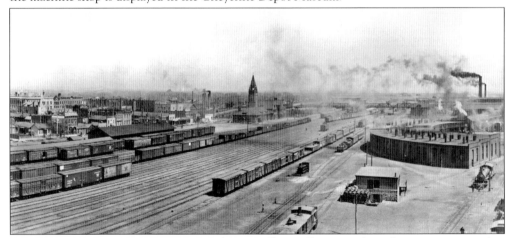

THE UNION PACIFIC YARDS, C. 1915. The 20-stall roundhouse to the right was constructed in 1890 and 1910. It was demolished in 1930 to make way for a new roundhouse; seven stalls of that roundhouse remain today. The earlier roundhouse could accommodate 20 locomotives that were 76 feet long. As the steam locomotives grew to 120 feet by the 1920s, a larger roundhouse was needed. A portion of the 1867 stone machine shop shows just to the right of the roundhouse. The small building in the foreground is the 1868 oil house, which remained in place until the 1970s. Note Fifteenth Street to the north of the yards. Part of it was still residential in 1915. The photograph was taken from atop the coaling dock. (Stimson.)

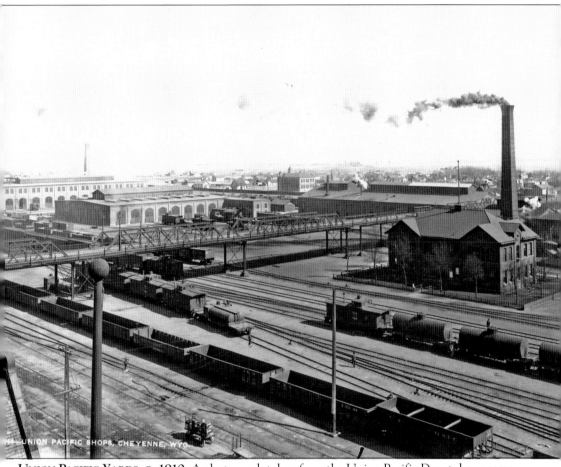

Union Pacific Yards, c. 1910. A photograph taken from the Union Pacific Depot shows some of the buildings in the railroad yards. The building to the far left is the 1890 tank shop that burned in 1941. The large building in front of the tank shop is the 1890 paint shop, later the supply department. It was demolished in 1974–1975. The mechanical building or the yard office is the two-story building to the right of the viaduct. The large chimney stack is part of the powerhouse. The Southside School is the two-story building in the rear center just to the left of the large blacksmith shop with the clerestory roof, which allowed natural light into the shop. (Stimson.)

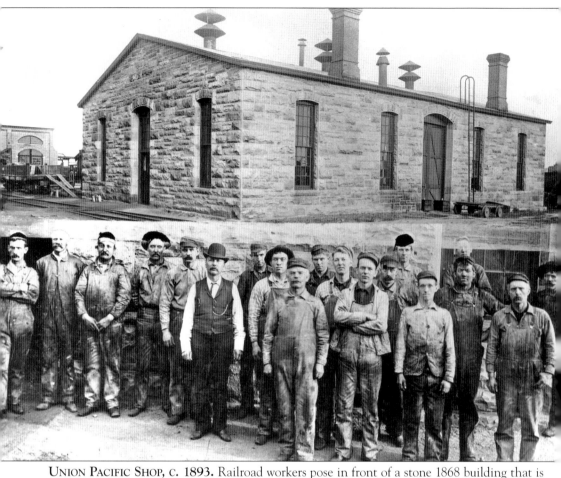

Union Pacific Shop, c. 1893. Railroad workers pose in front of a stone 1868 building that is either the blacksmith shop or the tin shop. A portion of an 1890 shop building with large windows shows to the left. Although the 1868 buildings were constructed of stone, the 1890 shops were built with brick. Shop foreman John McCabe is the man in the derby. The others are unidentified.

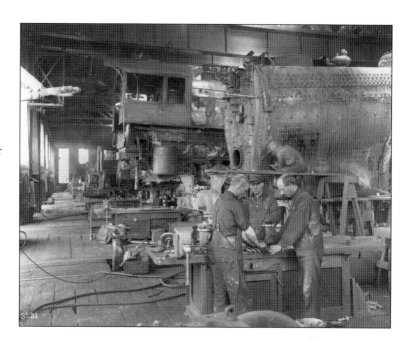

UNION PACIFIC MACHINE SHOP, 1911. The man on the platform is working on a steam boiler. Steam locomotives were labor-intensive and often required repair to the running gear and boilers. They were used by the railroad until 1946. Note the partially dismantled car that hangs from the ceiling. (Stimson.)

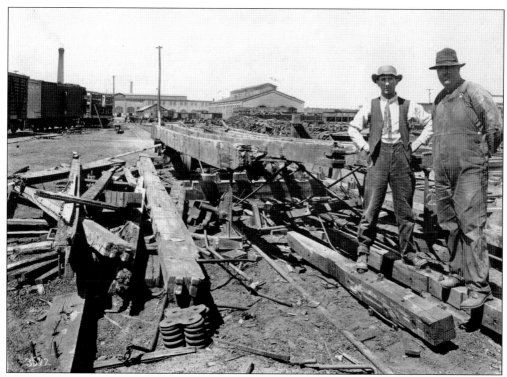

UNION PACIFIC YARDS, JUNE 23, 1914. The two men stand near a dismantled freight car. The large building to the left behind the men is the 1890 car shop. To the left of that is the 1890 tank shop. The smokestack above the freight cars is part of the heat plant. (Stimson.)

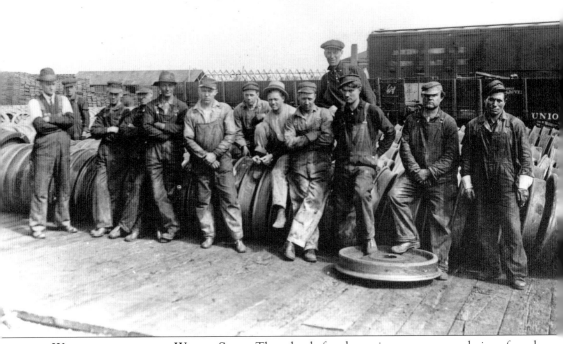

WORKMEN FROM THE WHEEL SHOP. The wheels for the train cars were made in a foundry elsewhere and shipped to the Cheyenne yards, where axles were fitted onto the wheels. By 1900, the Union Pacific employed over 2,000 men in Cheyenne.

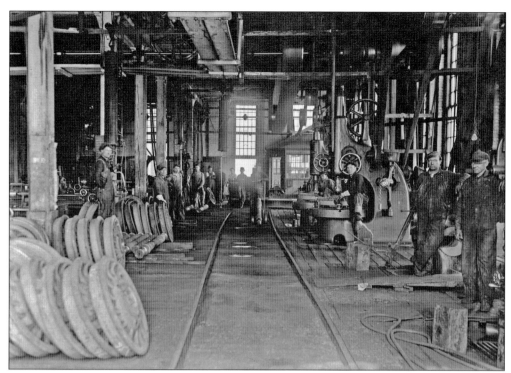

UNION PACIFIC WHEEL SHOP. A view of the inside of the wheel shop shows some of the same workers as in the previous photograph. Most of the 1890 shop brick buildings were sturdily constructed employing timber-framing techniques. (Stimson.)

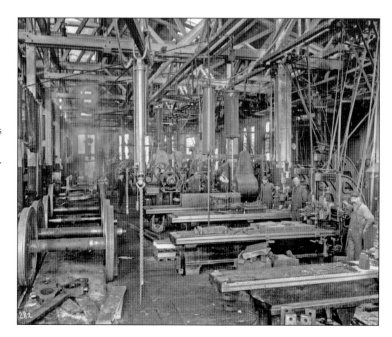

UNION PACIFIC MACHINE SHOP, 1911. The bulk of the 1890 buildings were demolished in the 1970s when the railroad no longer had use for them. The tons of machinery were made into scrap metal. All the shop buildings had large windows that allowed plenty of light into them. Part of the machine shop survives today and contains the vintage locomotives the railroad occasionally uses for excursion trains. (Stimson.)

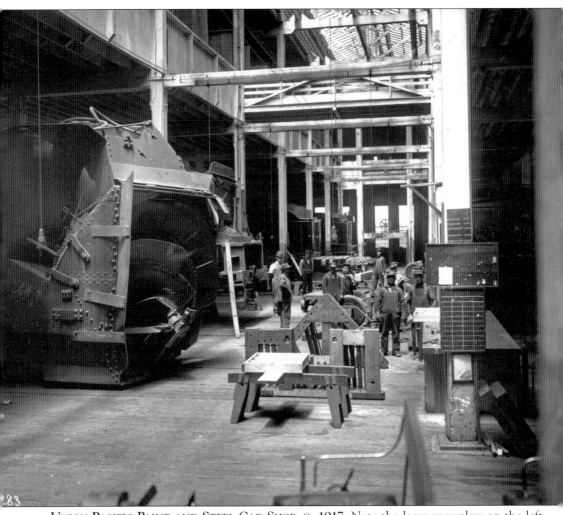

UNION PACIFIC PAINT AND STEEL CAR SHOP, C. 1917. Note the large snowplow on the left. Only 11 of this type of plow were ever built. Tenders show in the left background. The triangular piece of machinery in the front is part of a cowcatcher.

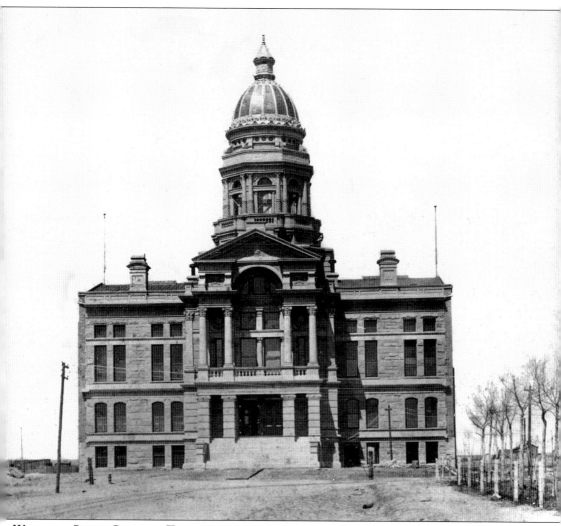

Wyoming State Capitol, Twenty-fourth Street and Capitol Avenue, 1887–1888. The territory of Wyoming did not have a capitol building until 1888. For years, the legislature met in various rented rooms throughout the downtown. In 1886, Gov. Francis E. Warren urged the Ninth Legislative Assembly to allocate funds for the construction of a capitol building, and they agreed. The Capitol Building Commission selected Toledo, Ohio, architect David W. Gibbs for the design, and another Ohio firm, A. Feick and Brother, won the bid for construction. The building was designed so east and west wings could be added later. The small trees on the right side of the photograph mark the west boundary of the City Park.

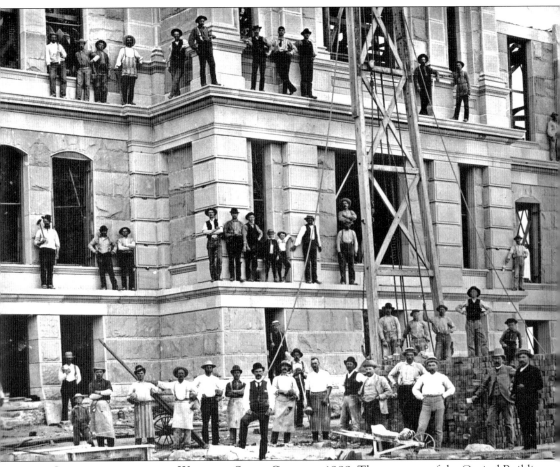

CONSTRUCTION OF THE WYOMING STATE CAPITOL, 1889. The presence of the Capitol Building and state government in Cheyenne contributed to the economy and prestige of the small city. The photograph shows the construction of the wing additions to the Capitol Building in 1889. Built of sandstone from Fort Collins, Colorado, and Rawlins, the construction employed many of Cheyenne's tradespeople and craftsmen. Contractor Moses Keefe managed the second phase of construction.

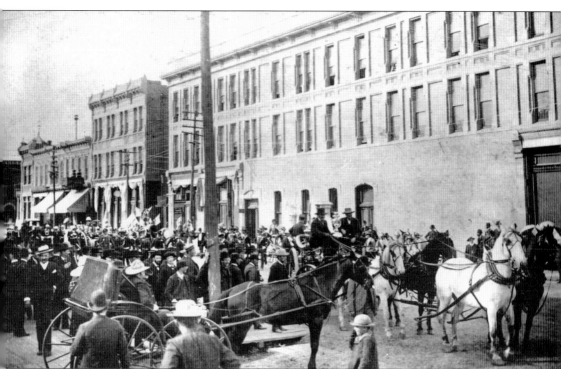

CAPITOL CORNERSTONE PARADE, SIXTEENTH STREET AND CAREY AVENUE. Businesses in Cheyenne closed at noon on May 17, 1887, in order to enjoy the cornerstone celebration. The parade began at 1:30 p.m. and included bicyclists, firemen, territorial and city officials, three bands, and Fort D. A. Russell troops. The parade is shown here on Carey Avenue in front of the Idleman Building on the right. It continued up Capitol Avenue to the unfinished building, where the crowd heard speeches from such prominent residents as Joseph M. Carey, then the territorial delegate to the U.S. Congress, and Gov. Thomas Moonlight.

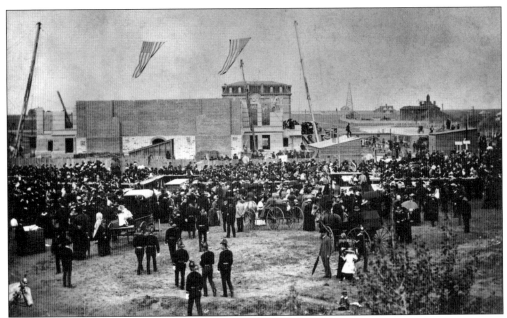

LAYING THE CORNERSTONE OF THE CAPITOL BUILDING, MAY 17, 1887. Plans for the cornerstone celebration included a large parade, barbeque, and dedication ceremony, all part of a major event in the 20-year history of Cheyenne. Over 4,000 people attended the festive celebration, which began with the parade. The academy of the Holy Child Jesus is visible to the far right in the photograph.

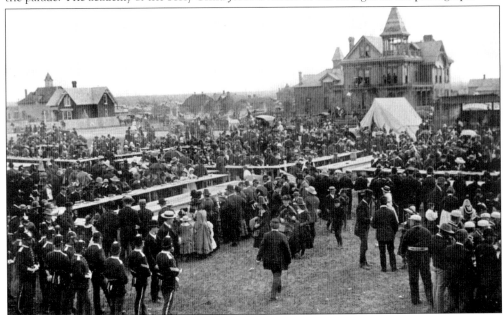

CAPITOL CORNERSTONE CELEBRATION. Tables were set up on the west side of the capitol for the barbeque after the parade and dedication ceremony. The barbeque, which included lemonade and pickles, reportedly fed over 4,000 people. The Hi Kelly house is visible behind the white tent. Hiram Kelly was a wealthy cattleman who ranched near Chugwater. His house stood on Carey Avenue across from the west side of the capitol until it was demolished in 1967 for a state parking lot where the state parking structure now stands.

Nine
THE NEW CENTURY

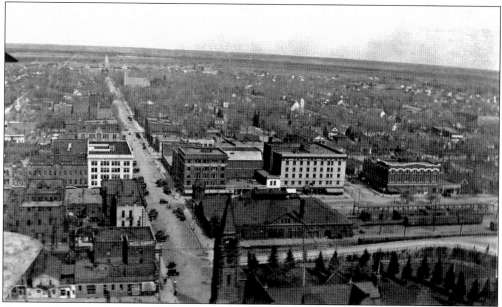

AERIAL VIEW OF CHEYENNE, LOOKING NORTH ON CAPITOL AVENUE, C. 1920. Sixteenth Street, the heart of downtown, had changed dramatically in 20 years. The large white building on the left is the Hynds Building, constructed on the site of the old InterOcean Hotel, which burned down. Directly across the street to the east is the Majestic Building. The original five-story Plains Hotel, before the 1927 addition, anchors the corner of Sixteenth Street and Central Avenue. Across the street to the east is the Gleason Building, known today as the Grier Furniture Building. F. E. Warren's 1880s Emporium, on the south side of Sixteenth Street across from the Majestic Building, functioned as the Burlington Railroad Depot. The city had not yet expanded north beyond the Capitol Building. Carey Avenue, the old Cheyenne-Deadwood Trail, is the only street that extends north beyond the city limits. Note the park on the east side of the Union Pacific Railroad Depot.

COLLAGE OF CHEYENNE BUILDINGS, 1902. This type of image was popular at the turn of the 20th century, especially for proud small towns and cities around the country. The image was meant to convey a modern city with amenities that were important to people then as they are now: a hospital, a large courthouse signifying law and order, a depot, the stability of a state capitol, and two large school buildings. They were promotional devices that helped lure new people to town, much like today's economic development efforts.

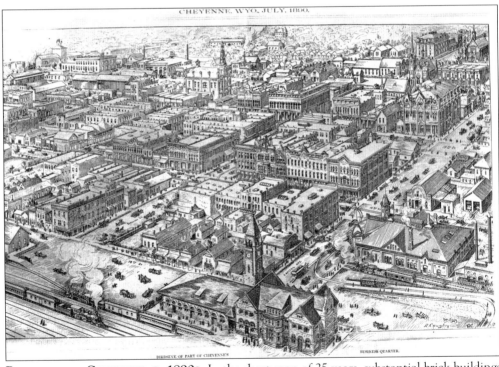

PANORAMA OF CHEYENNE, C. 1890S. In the short span of 25 years, substantial brick buildings had replaced the tent town and false fronts of early Cheyenne. The city's horse-drawn streetcar system began in 1888, and the viaduct connecting north and south Cheyenne was built sometime around 1890. Note the density of the downtown and the west side. The InterOcean Hotel is visible one block north of the depot on the corner, and the Cheyenne Opera House is one block north of the hotel.

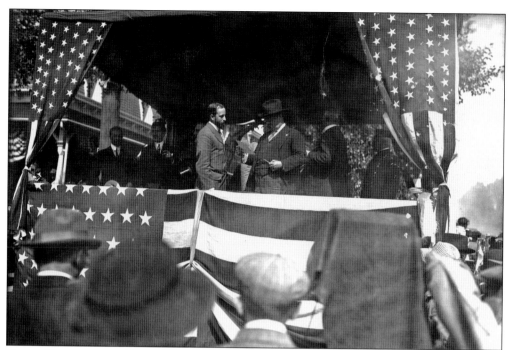

TEDDY ROOSEVELT IN CHEYENNE, AUGUST 1903. As president of the United States, Roosevelt paid a second visit to Cheyenne in 1903. He first toured Cheyenne in 1900 while he was governor of New York and campaigning for presidential incumbent William McKinley. Roosevelt succeeded McKinley as president in 1901 when the latter died after receiving gunshot wounds. In 1903, Roosevelt entered Cheyenne on horseback, riding from Laramie to Cheyenne accompanied by Sen. F. E. Warren, R. S. Van Tassell, and other dignitaries. Roosevelt is shown here on a speaker's platform at Seventeenth Street and Warren Avenue. A bit of the Cheyenne Club is visible on the left.

ALERT HOSE COMPANY DECORATED FOR PRES. TEDDY ROOSEVELT, 1903. The third of Cheyenne's four volunteer fire companies was organized in 1877. Located on the east side of Capitol Avenue between Seventeenth and Eighteenth Streets, Alert had their motto, "We Strive to Save," cut in stone above the prominent center window. Cheyenne's fire companies often held public competitions that included such events as ladder climbing and hose coupling contests. On Memorial Day, members of all four fire companies would march to Lakeview Cemetery and decorate the graves of their fallen comrades. The city established a paid fire department in 1909, which meant the end for the volunteer organizations. The Alert Hose Company building was razed in 1960. (Stimson.)

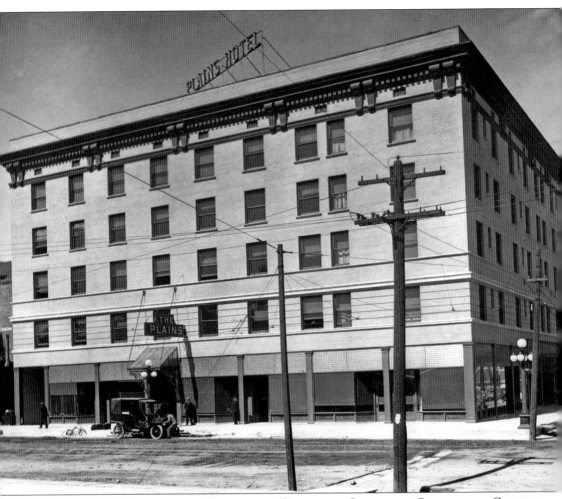

The Plains Hotel, 1911, Northwest Corner of Sixteenth Street and Central Avenue. The premier hotel of Cheyenne and Wyoming for many years, the Plains opened in March 1911. It was designed by Cheyenne architect William Dubois. The five-story building received a 50-room addition in 1927–1928, making it the state's largest hotel.

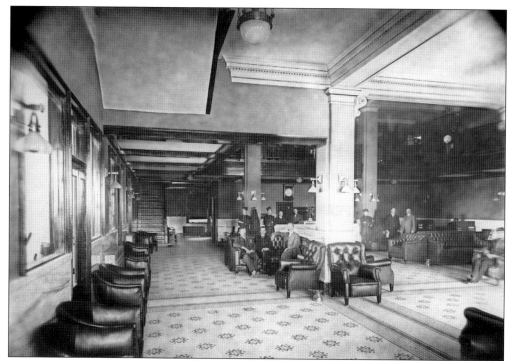

THE PLAINS HOTEL LOBBY, 1911. The first floor of the Plains featured a large lobby, the Indian Grill Room and cocktail lounge, and commercial space. Peacock Alley, a long hallway just off the lobby, linked Central and Capitol Avenues. Guests could relax in the mezzanine above the lobby where an orchestra often played. A nearby tearoom became a gathering place for the upper-crust women of Cheyenne. For many years, members of the Wyoming Legislature stayed at the Plains during the session, and political dealings took place in the building's watering holes and lobby. Note the bellhops and spittoons.

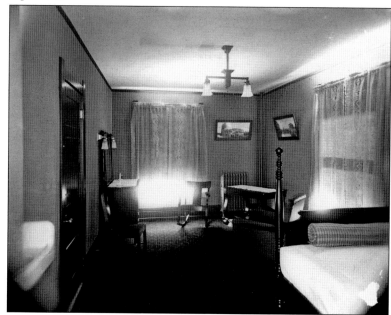

GUEST ROOM AT THE PLAINS HOTEL. The modern building contained 100 guest rooms, most with a private bath and telephone.

101

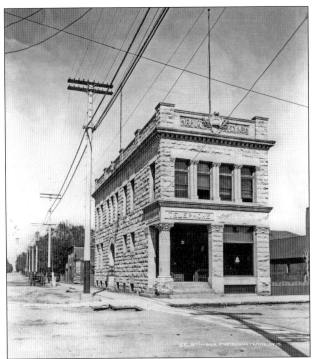

THE TELEPHONE BUILDING, SOUTHEAST CORNER OF CAPITOL AVENUE AND SEVENTEENTH STREET. The first long-distance telephone conversation in Wyoming occurred in 1878 between Frances E. Warren, E. A. Slack (editor of the *Cheyenne Daily Sun*), Bill Nye (editor of the *Laramie Boomerang*), and others. The Wyoming Telephone Company and various small exchanges merged to form the Rocky Mountain Bell Telephone Company in 1883. In 1906, the telephone company moved its office into a new building at a prime corner location in the downtown. In 1931, the company moved into new offices at 1919 Capitol Avenue. The building then became a hotel with a third-floor addition. (Stimson.)

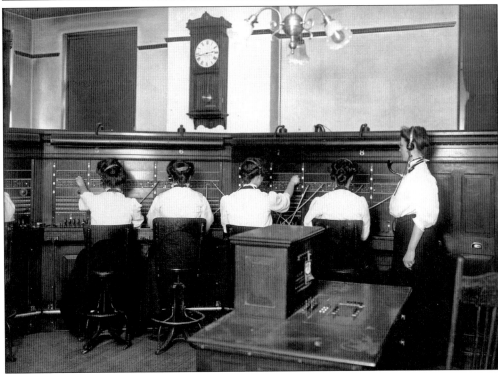

TELEPHONE OPERATORS. The "Hello Girls" operated the telephone switchboards. Rocky Mountain Bell Telephone Company became Mountain States Telephone and Telegraph in 1911, which was also the year the Plains Hotel opened and featured telephones in every guest room. (Stimson.)

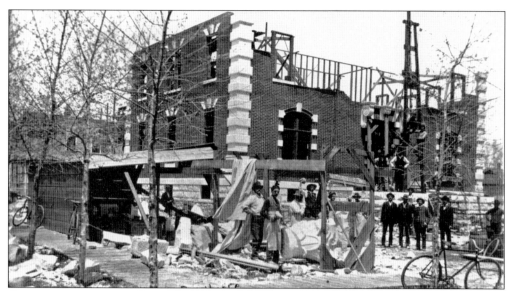

CONSTRUCTION OF THE GOVERNOR'S MANSION, 1904. For years, Wyoming territorial and state governors had lived in their own houses or rented quarters because of a lack of a formal governor's mansion. Omaha architect Charles Murdock designed Wyoming's first governor's mansion in the Classical Revival style that was popular at the time for large houses throughout the United States. J. R. Grimes was the builder of the structure featuring sandstone columns, quoins, and window details. The stonecutters in the photograph appear to be working on one of the columns. Note the bicycles that perhaps belonged to some of the workmen on the project.

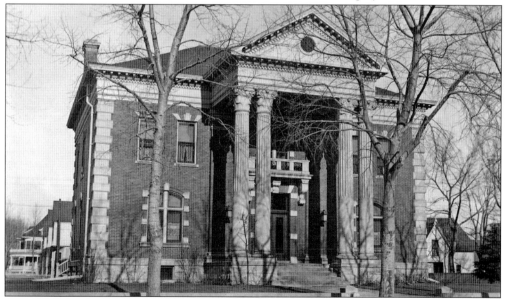

GOVERNOR'S MANSION, 300 EAST TWENTY-FIRST STREET, 1917. The two-and-one-story residence and carriage house was completed in 1905 for a total cost of $33,000, which included the lot, landscaping, and furniture. The house had central plumbing, hot water heat, and combination gas and electrical fixtures throughout. Gov. Bryant B. Brooks and his family of five children were the first to reside in the mansion. A pet pony lived in the carriage house. Governors of Wyoming occupied the building until 1976, when the second governor's mansion was constructed north of town.

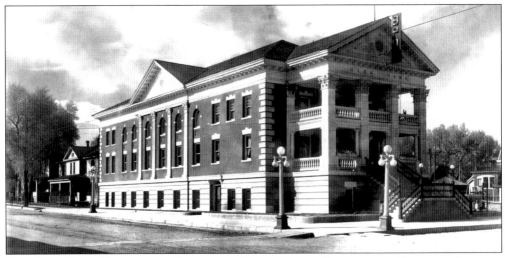

THE ELKS CLUB, NORTHEAST CORNER OF SEVENTEENTH STREET AND CENTRAL AVENUE, JUNE 3, 1916. This handsome Classical Revival–styled building, designed by the versatile William Dubois and constructed in 1903, housed one of Cheyenne's many fraternal organizations. Other such groups in Cheyenne included the Masons, the Eagles, the Odd Fellows, the Knights of Pythias, and the Modern Woodmen of America. Many men belonged to more than one club. The area was once primarily residential, as evidenced by the houses at the left. The building remains at the same location today although the exterior has been significantly altered. (Stimson.)

THE 1908 NEW YORK–TO–PARIS RACE, SEVENTEENTH STREET WEST OF CENTRAL AVENUE. Five cars from the United States, Germany, France, and Italy competed in the famous car race that began in New York City on February 12, 1908, and ended in Paris on July 30, 1908. Part of the American crew in their 1907 Thomas Flyer is shown here in a parade just west of the Elks Club at Central Avenue and Seventeenth Street. (Stimson.)

THE 1908 NEW YORK–TO–PARIS RACE, WEST SIDE OF CAPITOL AVENUE BETWEEN SIXTEENTH AND SEVENTEENTH STREETS. Two of the race cars are parked beside the InterOcean Hotel while a crowd looks on. The race cars sometimes rode on railroad tracks through areas where there were no roads. That may have been most of Wyoming, as the Lincoln Highway, the first transcontinental road, was not constructed until 1915. The Cheyenne Opera House is the large three-story building in the background. (Stimson.)

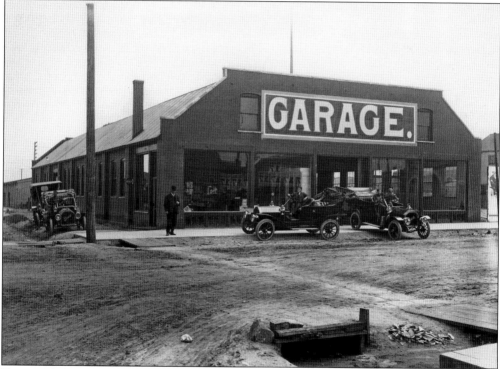

DINNEEN'S GARAGE, SOUTHWEST CORNER OF SIXTEENTH STREET AND PIONEER AVENUE, 1909. The Dinneen family arrived in Cheyenne in 1879. Brothers William E. and Maurice Dinneen established Dinneen Brothers Grocery in 1890 at the I. C. Davis Building on the northeast corner of Seventeenth Street and Pioneer Avenue. They also owned the Bon Ton Livery Stable. William Dinneen's first garage was located at the southwest corner of Sixteenth and Pioneer and had just been constructed at the time of this photograph. He became a dealer for Buick, Reo, and Hudson automobiles. He later owned a filling station next door to the garage. Dinneen's eventually moved across the street to their new building, which still stands at the northwest corner of Sixteenth and Pioneer.

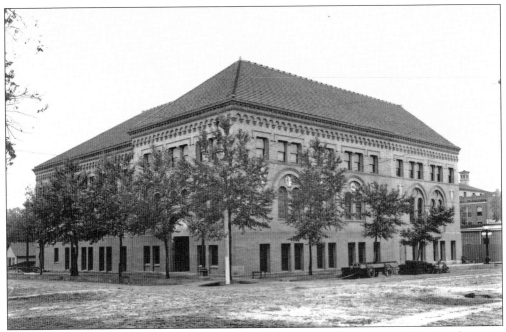

THE MASONIC TEMPLE, SOUTHWEST CORNER OF EIGHTEENTH STREET AND CAPITOL AVENUE, 1911. Construction of the William Dubois–designed temple began in 1901. The building replaced the original 1868 temple located on the north side of Sixteenth Street between Pioneer and Carey Avenues. The 1911 addition to the west side is visible in the photograph. (Stimson.)

DETAIL, MASONIC TEMPLE. The L. Moretti Glass Company of Omaha, Nebraska, did the mosaic tile work above the main entrance to the Masonic Temple. Much like one sees today, Moretti advertised his company at the site while performing his job.

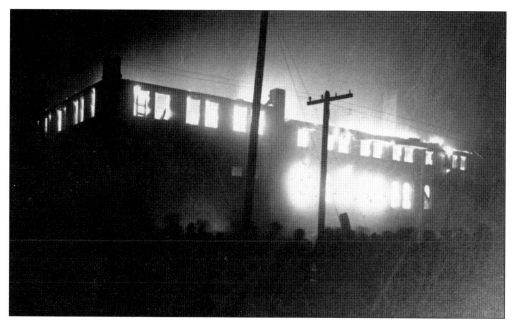

THE FIRE AT THE MASONIC TEMPLE, MARCH 1, 1903. According to the *Cheyenne Daily Leader*, the fire was discovered about 8:30 p.m. Lines of hose were stretched but there was not enough water pressure to reach the third floor. Flames shot 100 feet into the air. The firemen labored throughout the "bitter cold night," and five were injured. (Stimson.)

AFTERMATH OF FIRE AT THE MASONIC TEMPLE. The main portion of the temple was completely gutted. The reading room, the memorial hall, office, and club room could be reconstructed. The bowling alley, which had just been completed the week before, was also destroyed. The cause of the fire was believed to have been faulty electricity. The temple was quickly rebuilt and reopened in November 1903. (Stimson.)

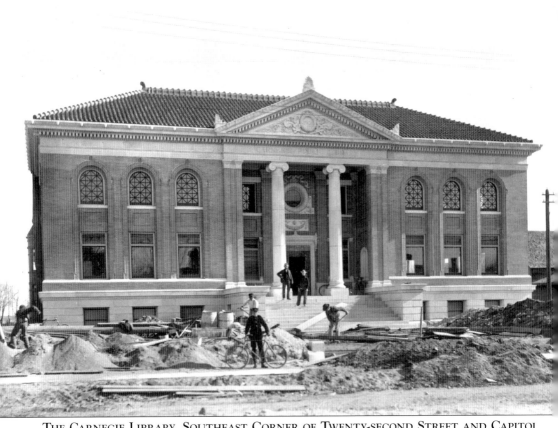

THE CARNEGIE LIBRARY, SOUTHEAST CORNER OF TWENTY-SECOND STREET AND CAPITOL AVENUE. The Carnegie Library, one of Cheyenne's crown jewels, opened in 1902. Local architect William Dubois designed the building that replaced the Laramie County Library, formerly located in two rooms at the Central School. The magnificent building housed a large reading room, a children's room, separate parlors for men and women, and an auditorium that could seat 350 people. Attempts to save the building failed, and it was demolished in 1971 and replaced by a bank building that now serves as offices for St. Matthew's Cathedral.

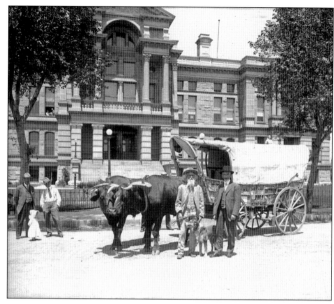

EZRA MEEKER AT WYOMING STATE CAPITOL, 1910. In 1852, the 21-year-old Ezra Meeker traveled from Iowa to Oregon by oxcart on the Oregon Trail. In the early 1900s, Meeker once again traveled the old trail by oxcart, this time from west to east. Along the way, he promoted the preservation of the Oregon Trail and gained national attention. Meeker made another such trek in 1910 and stopped in Cheyenne. Thanks to Meeker's efforts, Pres. Theodore Roosevelt allocated funds for preservation of the trail. (Stimson.)

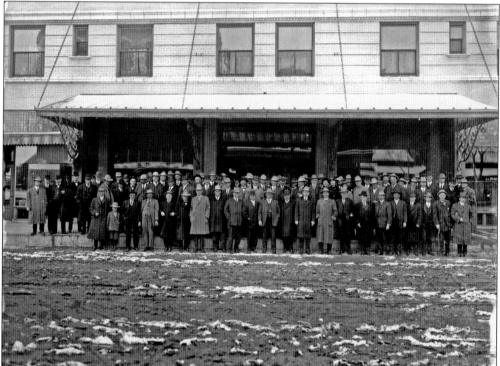

WYOMING STOCK GROWERS ASSOCIATION MEMBERS OUTSIDE THE PLAINS HOTEL, 1914. Established in late 1873 as the Laramie County Stock Growers Association and renamed the Wyoming Stock Growers Association in 1879, the organization had enormous economic and political power in Wyoming. Members included some of the most influential men in Cheyenne, such as Alexander Swan, Joseph Carey, Thomas Sturgis, R. S. Van Tassell, and William Irvine. By 1914, the Wyoming Stock Growers Association had 814 members. Its president, John B. Kendrick, became Wyoming's governor that same year. (Stimson.)

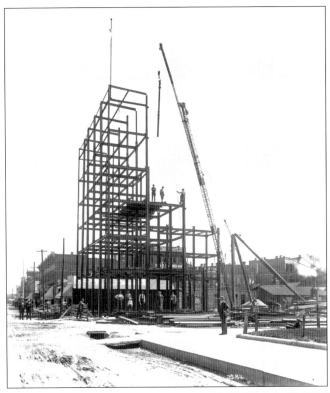

CONSTRUCTION OF THE BOYD BUILDING, 1912, SOUTHWEST CORNER OF EIGHTEENTH STREET AND CAREY AVENUE. Designed by Cheyenne architect Frederic Hutchinson Porter, the Boyd Building, six stories in height, was Cheyenne's tallest structure for many years. The crane in the photograph was certainly a novelty in Cheyenne at the time. The 40-year-old Carey Block is the large building just south of the construction.

THE BOYD BUILDING. The Boyd Building was originally the Citizens National Bank, in business at the Boyd until 1924 when it went under. H. N. Boyd then purchased the building in 1925 and also renamed it. Architect William Dubois redesigned much of the interior on the upper floors, which housed professional offices. Boyd first established a cigar store down the block in 1908. The business then moved to the first floor of the Boyd Building. City News has occupied the first floor since 1969. (Stimson.)

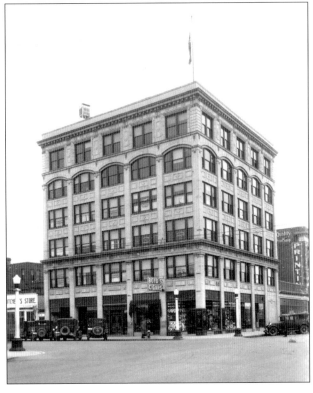

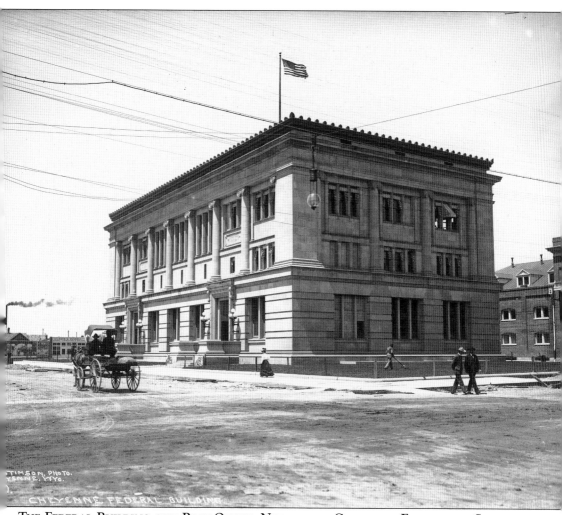

THE FEDERAL BUILDING AND POST OFFICE, NORTHWEST CORNER OF EIGHTEENTH STREET AND CAREY AVENUE, 1906. Occupying one-half of a square block, the Federal Building was located directly across the street from the First Presbyterian Church that occupied the northeast corner of Eighteenth Street and Carey Avenue. Constructed between 1898 and 1903 of native sandstone cut in Rawlins, the interior of the classically inspired building featured oak woodwork and gray marble. The famed attorney Clarence Darrow argued a murder case in the courtroom. The Federal Building was demolished in 1966–1967, and the entire square block is now occupied by a bank building. (Stimson.)

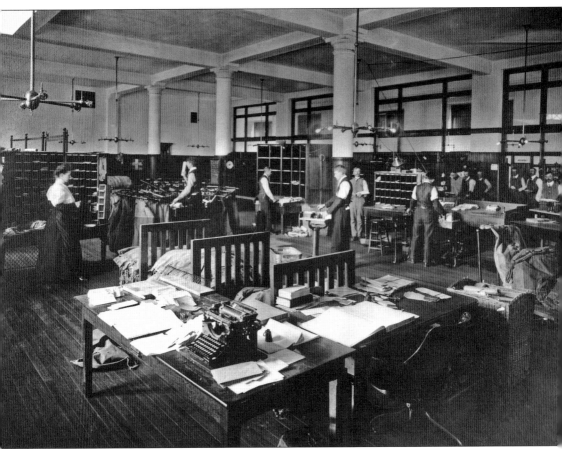

INTERIOR, NEW POST OFFICE AND FEDERAL BUILDING. A number of men and one woman are kept busy in the mail room of the new post office. In addition to the post office and federal courtrooms, the building housed the U.S. Land Office, U.S. Marshall's office, the U.S. Surveyor General's office, the U.S. Referees in Bankruptcy, the Office of Irrigation and Drainage, and the U.S. Weather Bureau.

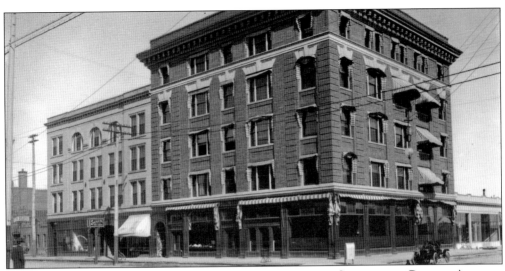

THE MAJESTIC BUILDING, NORTHEAST CORNER OF SIXTEENTH STREET AND CAPITOL AVENUE. Downtown Cheyenne was changing in the early 1900s. Large brick buildings with a distinctly modern look began to replace structures from the 1870s. The J. Abney Livery Stables had been at this corner, directly across from the Warren Emporium, for years. William Dubois designed the Majestic Building, constructed in 1907 for the First National Bank, founded by Amasa Converse of Converse and Warren Mercantile. The bank failed in 1924, and the building then housed offices and commercial operations. Today the round arched entry on the far left side of the building leads to Peacock Alley and the Plains Hotel. The Capitol Avenue Theater is just north of the Majestic, and next to that is the Dildine Livery Stable.

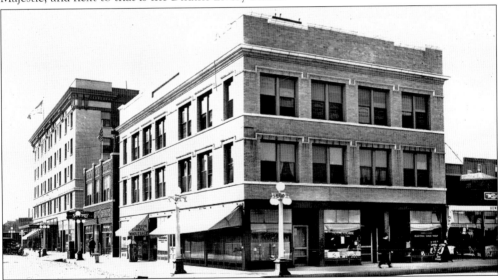

THE DEMING BUILDING, SOUTHWEST CORNER CENTRAL AVENUE AND SEVENTEENTH STREET, 1917. William Dubois designed this 1911 building, which still stands today on the same block as the Dubois-designed Plains Hotel. Much like Frances E. Warren, William Deming became a downtown real estate developer. Deming was born in Kentucky and came to Wyoming in 1901. He bought the newspaper the *Wyoming State Tribune* and consolidated it with the *Cheyenne State Leader* newspaper in 1920. He served as a Wyoming state legislator and became the president of the U.S. Civil Service Commission. (Stimson.)

FLOWER GARDEN IN LAKEVIEW CEMETERY, 1911. Cheyenne's first cemetery was located on the northwest side of town near Twenty-third Street and Ames Avenue. The cemetery then moved to a vacant area east of town. The first recorded burial in this cemetery was in 1875 for 2-year-old Daniel Cassells. The cemetery and the area around it are known as Lakeview because one could see the lake in Holliday Park before development of the surrounding area and large trees that now block the view. Such notables as Francis E. Warren, Joseph M. Carey, Renesselaer Van Schuyler, and Portugee Phillips are buried here.

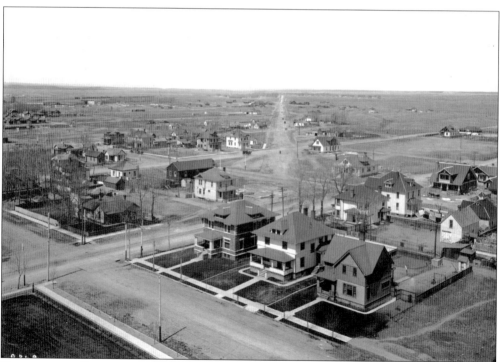

TWENTY-FIFTH STREET AND CAREY AVENUE, RANDALL AVENUE TO THE WEST, 1910. The city's residential area began to spread north and northwest beyond the Capitol Building. Substantial houses in the various styles of the period had been constructed along Carey Avenue and Pioneer Avenue. Note Randall Avenue heading off towards Fort D. A. Russell to the far west at the top of the photograph, which was taken from the Capitol Building. Two entire square blocks behind the capitol, bounded by Twenty-fifth and Twenty-sixth Streets and Carey and Central Avenues, were demolished in the early 1980s to make way for the state's Herschler Office Building. (Stimson.)

Ten
FRONTIER DAYS

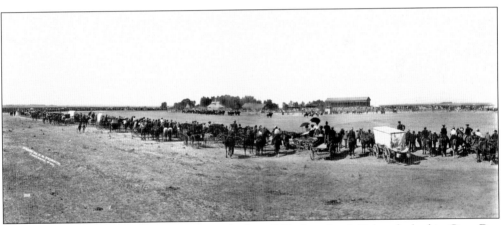

FRONTIER DAY, PIONEER PARK, 1902. By the late 1890s, Loveland, Colorado, had its Corn Day and Greeley celebrated Potato Day, but Cheyenne had no such annual festival. One of the city's biggest boosters, newspaper publisher Col. E. A. Slack, believed such an event would contribute to a floundering local economy and help put Cheyenne on the map. In 1897, Slack met with Frederick Angier, a Union Pacific employee in charge of arranging excursion trains for the railroad, who had come up with the idea of Cheyenne hosting some type of annual celebration that featured horses, cowboys, riding, and roping—essential skills every ranch hand needed. A few days later, Slack advertised the upcoming one-day event, which would take place September 23, 1897. (Stimson.)

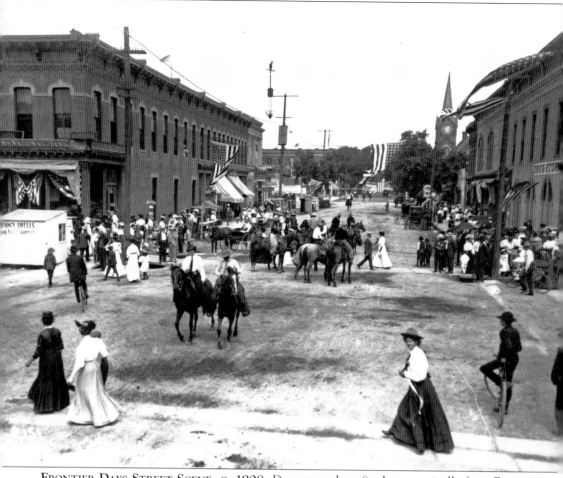

Frontier Days Street Scene, c. 1908. Downtown benefited economically from Frontier Days. Excursion trains brought thousands of people to Cheyenne, and thousands more of the city's residents also took part in the festivities. Local hotels, boardinghouses, and restaurants were filled to capacity, and the Frontier Days Committee asked residents to help provide rooms and meals to visitors. Vendors set up on the streets and hawked souvenirs, food, and drink. Individual buildings were decorated with flags for the celebration. The photograph is looking north on Carey Avenue from Seventeenth Street. Note the number of cyclists and also the vendor in front of the bank selling "Fancy Shells and Rustic Souvenirs." The tower of the First Presbyterian Church is on the right.

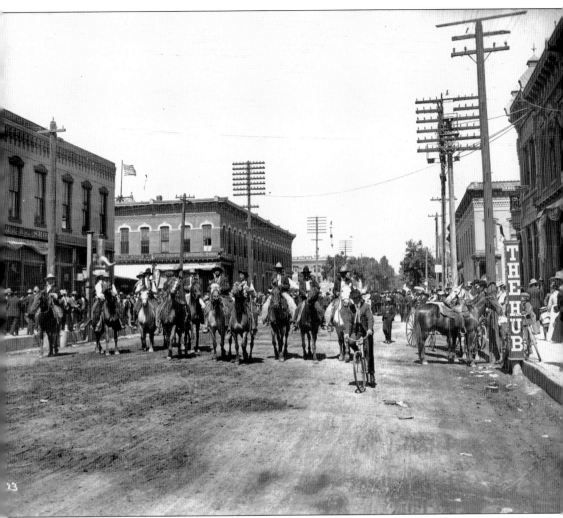

ANTICIPATING THE PARADE, UP CAREY AVENUE BETWEEN SIXTEENTH AND SEVENTEENTH STREETS. The first Frontier Day parade took place in 1898 when Buffalo Bill Cody's Wild West Show came to town in conjunction with the event. A parade through downtown featured the hundreds in Cody's troupe, 200 Cheyenne firemen, a wagon train, and the Deadwood Stage Coach, as well as cowboy contestants. Cody's show took place where the Avenues residential area is today. Whooping and hollering cowboys were the main act of the early parades. Bands such as the Capital City Band, the 11th Infantry Band from Fort D. A. Russell, and others might come from Denver or farther away. The bands also played at concerts and street dances at which canvas was laid down to cover the dirt. Today there are four parades during the 10-day celebration.

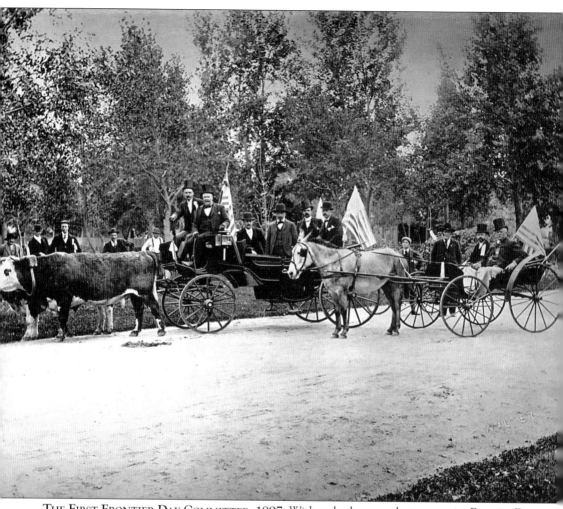

THE FIRST FRONTIER DAY COMMITTEE, 1897. With only three weeks to organize Frontier Day, the local businessmen and city kicked into high gear. Ranchers agreed to send a few of their cowboys and horses to participate in such events as steer roping, a wild horse race, cow pony races, and bronco riding. Slack frequently advertised the event in his paper to build interest in the big celebration. A Frontier Day Committee was formed, with Tivoli owner Warren Richardson serving as chairman. Pioneer Park, west of town and site of the old Territorial Fair on the former Talbot homestead tract, included a number of barns, a grandstand, and a half-mile track used by the Cheyenne Racing and Driving Club in the 1880s. In the photograph taken at the City Park, Richardson is sitting in the driver's seat to the left in the front barouche and Slack is seated in the phaeton on the right.

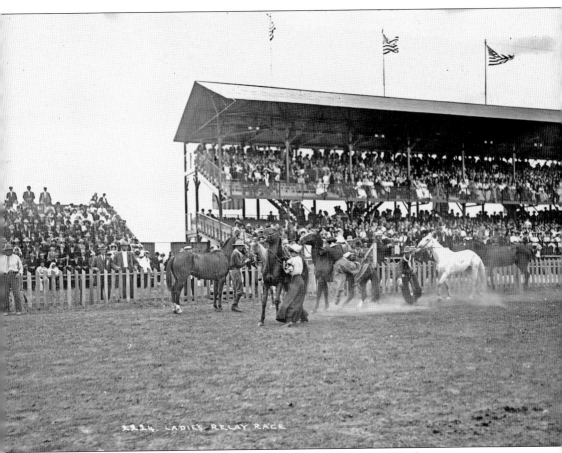

LADIES' RELAY RACE. Women first participated at Frontier Days in 1899 when a woman won a $45 saddle in the half-mile race. They performed in three events: cow pony races, bronc riding, and a relay race. They also entertained in trick riding competitions beginning in 1911. The women's events were very popular, and some of the competitors, like Prairie Rose Henderson, became stars on the rodeo circuit. (Stimson.)

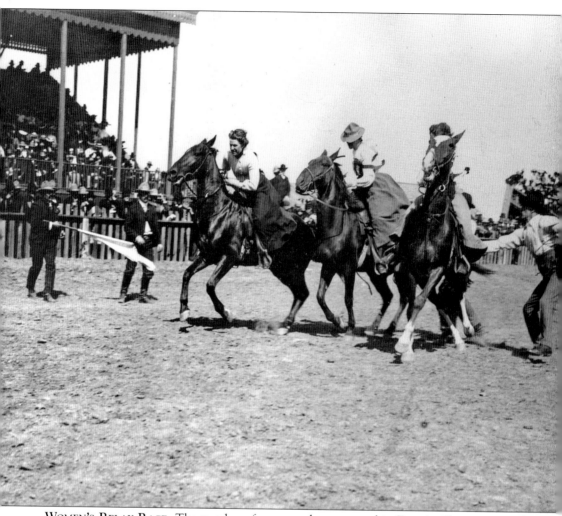

WOMEN'S RELAY RACE. The number of women who competed in Frontier Days continued to grow during the first two decades of the 20th century. In 1919, twenty women entered the various contests. Most women's events were eliminated after World War II, and today they compete only in barrel racing and trick riding at Frontier Days. (Stimson.)

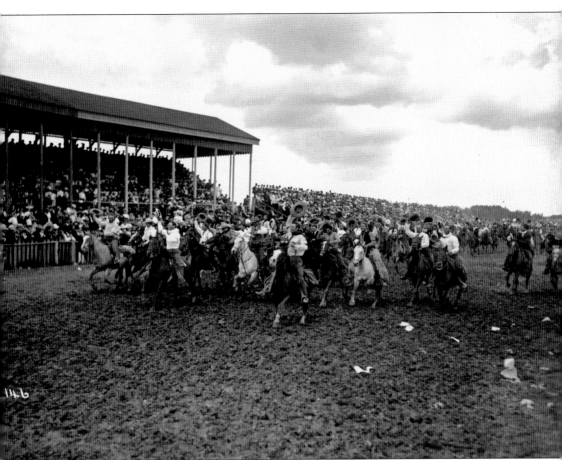

FRONTIER DAYS, 1908. The first Frontier Day drew 4,000 people and was such a success that the committee decided to make it a two-day event in 1898; it expanded to three days in 1907. Due to weather conditions, the celebration was moved up to August in 1899, although it was held in September during other years until 1915, when it became a permanent fixture during the last full week of July. The photograph shows the new 1908 grandstand erected at a different location north of town, land that the city owned and leased back to the Frontier Committee. In the photograph, cowboys parade in front of the grandstand before the official program begins. (Stimson.)

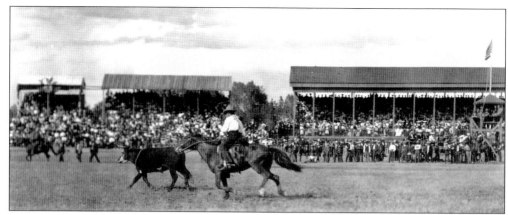

STEER ROPING EVENT. The first cowboys at Frontier Days were primarily local ranch hands who brought their horses with them. Competition at the first Frontier Day in 1897 included a cow pony race, a free-for-all one-mile race, a pitching and bucking horse event, and a wild horse race. As seating was limited to one grandstand, visitors surrounded the track railing and stood or watched from a carriage or wagon. A mock battle by troops from Fort D. A. Russell, a pony express ride, and a stagecoach holdup rounded out the day's events. Admission to the celebration was free, but an entry fee for contestants added to the purse for the winners. (Stimson.)

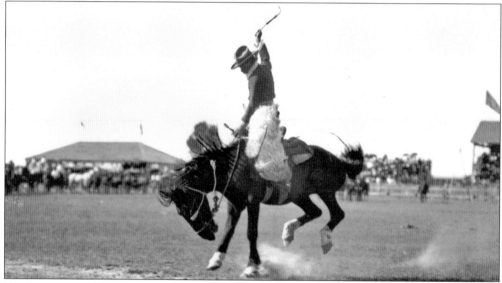

ED CARVER ON STEAMBOAT. The bucking horse Steamboat has become a legend among the thousands of steeds that have participated in Frontier Days over the years. Jet black in color and never quite tamed, Steamboat was born in 1896 on a ranch near Chugwater, Wyoming, and later sold to the Swan Land and Cattle Company's Two Bar Ranch. He first appeared in Cheyenne in 1905 and became famous as an "outlaw" horse. In 1907 and 1908, Steamboat received a significant honor by being selected as the Worst Bucking Horse of the Year at Frontier Days. In the early rodeo competitions, the horse was often more famous than the cowboys who rode them. Steamboat died in 1914, put down with the rifle of the notorious Tom Horn, after blood poisoning set in as a result of cuts from a wire fence. But Steamboat lives today throughout Wyoming, as he became the model for the University of Wyoming's bucking horse logo in 1921. Many believe the state's license plate is also modeled after Steamboat, although that claim has never been substantiated. (Stimson.)

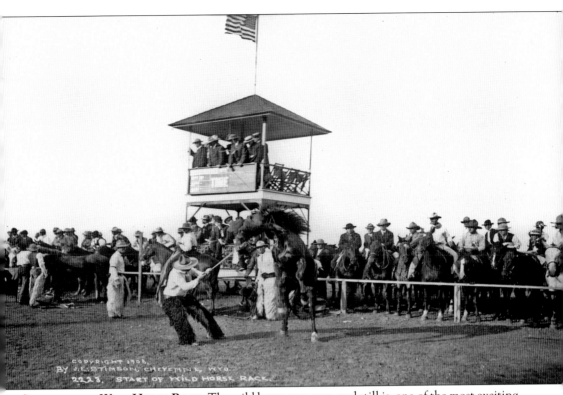

START OF THE WILD HORSE RACE. The wild horse race was, and still is, one of the most exciting events in rodeo. The riders were usually cowboys familiar with breaking horses.

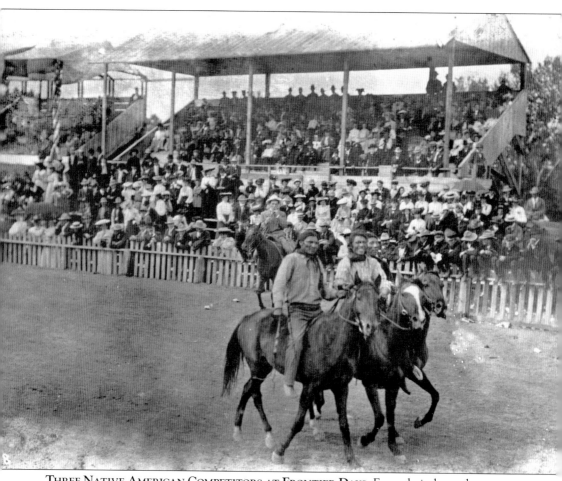

THREE NATIVE AMERICAN COMPETITORS AT FRONTIER DAYS. From their dress, the men appear to be cowboys and perhaps had just participated in an event. No Native Americans took part in the first Frontier Day, and their absence was noted by Colonel Slack, who opined in his newspaper that "some noble red men" would attend the 1898 event. Note that most of the women in the grandstand are dressed alike in white blouses, dark skirts, and large hats. (Stimson.)

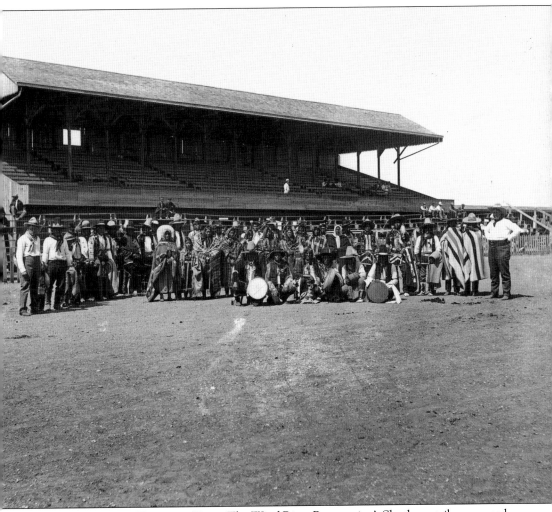

NATIVE AMERICANS AT FRONTIER DAYS. The Wind River Reservation's Shoshone tribe appeared at Frontier Days in 1898 along with the Sioux from Buffalo Bill's Wild West Show. During the parade, the Native Americans chased "pioneers" down Carey Avenue and attacked an emigrant train as part of the rodeo show. Native Americans camped in Pioneer Park at the old fairgrounds and cooked over campfires. When former president Theodore Roosevelt attended Frontier Days in 1910, members of the Sioux and Shoshone tribes participated in the festivities.

BIBLIOGRAPHY

Adams, Judith. *Cheyenne: City of Blue Sky*. Northridge, CA: Windsor Publications, Inc., 1988.
Arnold, Bess, and James L. Ehernberger. *Union Pacific Depot: An Elegant Legacy to Cheyenne*. Cheyenne, WY: Challenger Press, 2003.
Cheyenne Historic Downtown Walking Tour, Cheyenne Downtown Development Authority, 2005.
Cheyenne's Historic Parks: From Untamed Prairie to a City of Trees. Cheyenne, WY: Cheyenne Historic Preservation Board, 2001.
Cheyenne Historical Committee. *Cheyenne: The Magic City of the Plains*. Cheyenne, WY: self-published, 1967.
Cook, Malcolm L. *First Church: A People Called Methodist*. Cheyenne, WY: The First United Methodist Church, 1993.
Di Angelis, Gina. *The Black Cowboys*. Philadelphia, PA: Chelsea House Publishers, 1998.
Dubois, William R., and Shirley Flynn. *We've Worked Hard to Get Here: The First One Hundred Years of the Greater Cheyenne Chamber of Commerce*. Cheyenne, WY: Greater Cheyenne Chamber of Commerce, 2007.
Dubois, William III, James L. Ehernberger, and Robert R. Larson. *Cheyenne Landmarks, Laramie County Chapter*. Wyoming State Historical Society, 1976.
Early Cheyenne Homes: 1880–1890. Laramie County Historical Society, 1964.
Field, Sharon Lass. *History of Cheyenne, Wyoming: Laramie County Volume 2*. Dallas, TX: Curtis Media Corporation, 1989.
Flynn, Shirley E. *Let's Go, Let's Show, Let's Rodeo: The History of Cheyenne Frontier Days, the "Daddy of 'Em All."* Villa Park, IL: Wigwam Publishing Company, 1996.
Hanesworth, Robert D. (Bob). *Daddy of 'Em All: The Story of Cheyenne Frontier Days*. Cheyenne, WY: Flintrock Publishing Company, 1967.
Holland, Maj. Stephen L., ed. *From Mules to Missiles: A History of Francis E. Warren Air Force Base and its Predecessors Fort David A. Russell and Fort Francis E. Warren*. Francis E. Warren AFB, WY: unpublished report, 1987.
Junge, Mark. *J. E. Stimson: Photographer of the West*. Lincoln, NE: University of Nebraska Press, 1985.
Morton, Katherine A., and William R. Dubois. *Century of Service: First Presbyterian Church, Cheyenne, Wyoming 1869–1969*.
Moulton, Candy Vyvey, and Flossie Moulton. *His Life and Times: Steamboat Legendary Bucking Horse*. Glendo, WY: High Plains Press, 1992.
O'Neal, Bill. *Cheyenne: A Biography of the "Magic City" of the Plains*. Austin, TX: Eakin Press, 2006.
Riske, Milt. *Cheyenne Frontier Days: "A Marker From Which to Reckon All Events."* Cheyenne: Frontier Printing, 1984.

Rosenberg Historical Consultants. National Register of Historic Places Registration Form. Fort D. A. Russell–Francis E. Warren Air Force Base, Laramie County, WY: 2002.
Sanborn Map Company, Cheyenne: 1883; 1890; 1894; 1907; 1912.
Spring, Agnes Wright. *The Cheyenne Club: Mecca of the Aristocrats of the Old-Time Cattle Range.* Kansas City, MO: Don Ornduff, 1961.
Trenholm, Virginia Cole, ed. *Wyoming Blue Book, Volume 1.* Wyoming State Archives and Historical Department.
Van Pelt, Lori. *Capital Characters of Old Cheyenne.* Glendo, WY: High Plains Press, 2006.

Discover Thousands of Local History Books
Featuring Millions of Vintage Images

Arcadia Publishing, the leading local history publisher in the United States, is committed to making history accessible and meaningful through publishing books that celebrate and preserve the heritage of America's people and places.

Find more books like this at
www.arcadiapublishing.com

Search for your hometown history, your old stomping grounds, and even your favorite sports team.

Consistent with our mission to preserve history on a local level, this book was printed in South Carolina on American-made paper and manufactured entirely in the United States. Products carrying the accredited Forest Stewardship Council (FSC) label are printed on 100 percent FSC-certified paper.